FAMOUS JAPANESE
SWORDSMEN

FAMOUS JAPANESE
SWORDSMEN

of
The Warring States Period

William de Lange

日本の剣豪

FLOATING
WORLD
EDITIONS

First edition, 2006

Published by Floating World Editions, Inc.
26 Jack Corner Road, Warren, CT 06777
www.floatingworldeditions.com

Printed in the U.S.A.

ISBN 1-891640-43-7

Library of Congress Cataloging-in-Publication data available

For Akita Moriji Sensei

CONTENTS

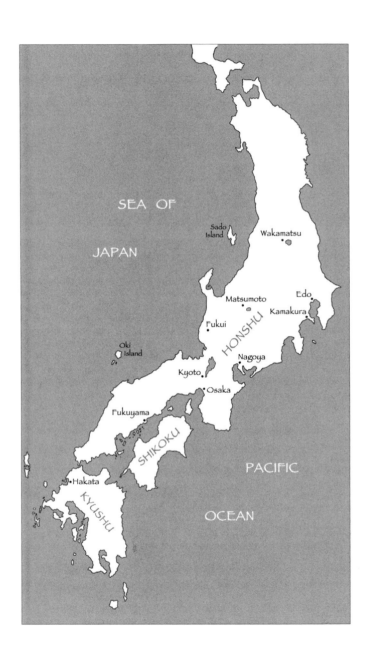

INTRODUCTION

No history of Japan's medieval era can be fully told without touching on the lives and exploits of its chief protagonists: the warriors. During the first two centuries of this era (from the rise of the military at the end of the Heian period in 1185 to the overthrow of the Kamakura Bakufu in 1333), their chief weapon was the bow and arrow; the sword played only a marginal role and, as far as records go, this period produced no great swordsmen of note. It is only later, in the century following the overthrow of the Kamakura Bakufu, when war became incessant, that the quintessential Japanese swordsman makes his debut and that we begin to see the first traces of a developing Japanese fencing tradition. Over the next century, as Japan was increasingly drawn into the vortex of civil strife, these first attempts at systemization were gradually forged into distinct schools of fencing. Finally, with the drive toward unification and pacification, the many schools of fencing that survived the turmoil of the previous centuries were consolidated into a fencing tradition that came to dominate the martial arts of the Edo period.

The living history of the origin, growth, and maturation of Japanese swordsmanship, then, roughly spans the period from the beginning of the fourteenth century to the first decades of the seventeenth century—an epoch that can be divided into three distinct periods: the Two Courts period (1333–92), the Warring States period (1469–1573), and the period of Unification (1573–1615).

This book tells the story of the two greatest swordsmen of the Warring States period. Their names are Iizasa Chōisai Ienao and Kamiizumi Ise no Kami Nobutsuna. Taken together, their lives span the period during which Japan was thrown into profound turmoil. This period of roughly a century was one in which the hapless Japanese citizenry was subjected to some of the most gruesome suffering endured by any people at any time. It was a time in which not a year passed without large parts of Japan being rent by internecine warfare, a time so aptly characterized by that great historian George Sansom when he invoked the opening words from Tacitus's famous history of the first dynasty of imperial Rome: "The history upon which I am entering," Tacitus warned his readers, "is rich in disasters, dreadful in its battles, rent by its seditions and even cruel in its peace." So it was with the times in which our two protagonists successively lived.

The period, known to the Japanese as the Senkoku Jidai, begins with the outbreak of the Ōnin War in 1467 and ends with the first drive toward Japan's pacification under Oda Nobunaga. It was in the wake of the Ōnin War that a tide of anarchy began to sweep the countryside that had no equal in Japanese history. As such, the Ōnin War marked a watershed. In the preceding century, there had been method in the madness of warfare. The conflict had been chiefly between two parties, a Northern and a Southern court, each with a clear objective: the right to rule the country. In the century or so following the Ōnin War, any such goal was hard to find, if not wholly absent. By then the conflict had deteriorated into an orgy of death and destruc-

tion in which all participated with equal relish yet none seemed to know exactly why, apart from that it served some immediate, self-serving purpose.

The lives of our two protagonists not only coincided with this period of civil warfare but indeed bore close witness to these terrible events. Though neither of them was of sufficiently high birth to leave his mark on the larger course of Japanese feudal history, both played their own unique and in many ways highly illustrative roles in a number of pivotal events during this century of unrelenting warfare. Iizasa Chōisai Ienao was present when, during the first few terrible months of the Ōnin War, the capital of Kyoto was almost completely reduced to ashes. And Kamiizumi Ise no Kami Nobutsuna played his own modest role in the great rivalry between those two towering figures in the checkered landscape of Japan's Warring States period, Uesugi Kenshin and Takeda Shingen.

The reader will soon find that in the telling of the story of these two remarkable men, much space has been given to the wider military and political events through which they lived. There are a number of reasons why this should be so. For one, to anyone interested in the history of Japanese martial arts it will be of some interest to know under what political and social conditions such military traditions flourished. The fact, for instance, that even relatively humble men such as Nobutsuna were valued to the extent that they were granted an audience with none other than Emperor Ōgimachi—a being considered divine—can only be fully appreciated when we realize that the selfsame Ōgimachi owed the partial

restoration of his office to a far greater feudal hero, Japan's first great unifier, Oda Nobunaga.

Political and social events shape an age and influence the actions of the people by which it is populated. It is no different with our protagonists. How, for instance, can we fully understand the forces that drove Ienao to renounce the world and become a Buddhist monk unless we have learned of the atrocities he witnessed during his ten years in the capital during the Ōnin War, unless we know of his exposure to the decadence of the Bakufu court—a court at which he served and to which he gave the best ten years of his life.

This broader perspective may also serve to put the contributions of these men into their proper proportions. It is in the nature of the histories of heroes that they grow more extravagant with each following generation, until, in the end, their lives and exploits have become distorted beyond recognition. One of the aims of this book is to place these men firmly back in their proper context, in the place and time in which they lived, and, in doing so, recapture some of the atmosphere of the Warring States period—how it must have been to be a warrior in a time so rife with difficulties yet so rich in opportunities.

It is, of course, no coincidence that these two remarkable men should have lived during these trying times. It could only have been such times of upheaval and constant warfare that produced such men. It was during these times, after all, when thousands upon thousands of warriors either perished or survived simply on the strength of their martial skills. At the end of the day, only those with superior skills and the

most effective techniques remained standing on the field of battle. These same factors ensured the survival of certain schools of Japanese fencing and the demise of others.

Japan's long feudal history produced many swordsmen of note, but among them Ienao and Nobutsuna stand out in particular, for each of them stood at the cradle of one of the schools that came to dominate the art of fencing during the Edo period, the Shintō and the Shinkage schools of fencing. It is evidence of the superiority of the techniques developed by our protagonists that, in one form or other, each of the two schools of fencing that they fathered has survived to this day.

It is remarkable, then, that so very little has been written about these men. Even in Japan, where so much weight has traditionally been given to pedigree and heritage, only a few books have been written on the origins of each school and even fewer about the lives of the two men who founded them. This does not mean that there are no sources to draw on, but they remain thinly spread, and the few morsels of historically reliable data that can be found have to be carefully gleaned from a wide variety and, at times, most unexpected of sources.

Given the nature of the subject, the great majority of sources tend to indulge in hyperbole to some extent. In the same way the famous war tales such as the *Heike monogatari* and the *Taiheiki* tend to exaggerate the number of troops that engaged in the battles they describe, so the few historical sources that mention our heroes are riddled with inaccuracies, embellishments, or outright fabrications. It is the modest aim of this work to carefully filter out the hyperbole

and, in doing so, represent our two protagonists and their exploits in the true light of historical fact, in the profound belief that even their unembellished lives are sufficiently remarkable to merit our attention. If, in the telling of their tales, our heroes stand to lose some of their legendary luster, it is hoped that at the same time they gain some of that essential humanity that, in spite of all the bloodshed and horrors of the Warring States period, never wholly left Japan, even during its darkest hours. It was that spark of humanity after all—the quest for an honest, simple, and quiet life—that not only characterized the lives of these two men, but also overcame the darker forces in human nature and eventually helped restore peace to a war-torn nation.

IIZASA CHŌISAI IENAO
(Iizasa Yamashiro)

飯篠長威斎家直

Genchū 4 –Chōkyō 2
(1387 –1488)

Whenever we turn to the great mystery of the wellspring of genius and ponder on the immensely diverse and ultimately unfathomable factors that contribute to a man's greatness, it is almost by instinct that we first turn our attention to the locality that brought forth the object of our admiration. The province of Shimōsa brought forth the famous warrior-monk Nennami Okuyama Jion, the greatest Japanese swordsman of the fourteenth century and founder of the Nen school of fencing. And it was the province of Shimōsa that brought forth the greatest swordsman of the century that followed. Is it mere coincidence that both were born within less than fifty miles of each other, or is there

some hidden bond that connects the two? Are the lives of both men like strands in a rope that ties all the great swordsmen in Japanese history together in the greater tradition of Japanese martial arts? There is much to suggest so. Indeed, even the most imposing feature of Shimōsa's landscape seems to impress upon us the sense that there existed an almost physical connection between these two towering yet distant figures in the history of Japanese fencing. This feature is the Tone River, that great and majestic watercourse that springs at the foot of Mount Tango in the Mikuni mountain range and flows across the width of the Kantō Plain and into the Pacific Ocean at the eastern extremity of the province of Shimōsa after a journey of more than one hundred and fifty miles. Every day of every year the same mountain water that fed the Tega Marshes near Jion's hometown of Fujigatani drifted calmly past the village of Sawara, the town so closely connected to the life of the greatest swordsman to emerge during the Warring States period, Iizasa Yamashiro.

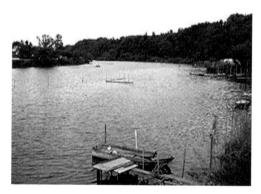

View of the old course of the Tone River

Mikuni mountain range, source of the Tone River

Though Yamashiro spent much of his childhood on the banks of the Tone River, he was not a native of Sawara. He was born in the hamlet of Iizasa, some twenty miles southwest of Sawara. It was near this small hamlet of only a dozen dwellings in the district of Senda, at the heart of the province of Shimōsa, that his clan owned a small estate. And it was from Iizasa that the clan into which Yamashiro was born derived its name. Not much is known about the family history of the Iizasa clan itself, but what is certain is that they were a distant strand of the Chiba clan.

The Chiba clan hailed all the way back to the beginning of the Heian period, to the illustrious Taira Takamochi, the grandson of Emperor Kanmu. Takamochi had been made *suke*, or vice-governor, of Kazusa province in 824. He had prospered and begotten nine sons, who had all settled in the eastern provinces and contributed to the growing power of the Taira clan. One of them, Taira Yoshimoji, initially took up a government post in the province of Sagami, but after a

3

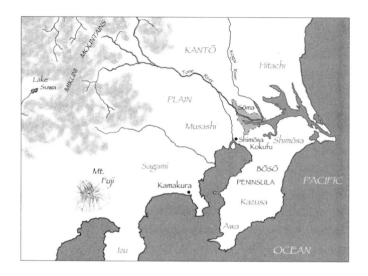

long and distinguished military career, eventually settled in the province of Shimōsa to succeed his father as vice-governor of Kazusa. His eldest son, Tadayori, who was born in Sagami, followed the same career as his father, occupying various military posts, until he too eventually settled in Shimōsa to succeed his father as vice-governor. By the time Tadayori's son, Tadatsune, was born in 975, the Taira had established a firm foothold in the Kantō region, with large holdings of land throughout the provinces of Kazusa and Shimōsa, which they controlled from a luxurious mansion in the Sōma district, a fertile stretch of land at the confluence of the Tone and Kogai rivers. As vice-governors appointed by the throne, the successive leaders of the Taira clan owed their fortunes to the imperial court. The local symbol of that central authority was the Kokufu, the seat of government of

4

the provincial governor, for whom they had rendered distin-
guished service and to whom they were beholden for the
emperor's continued patronage. That tradition came to an
abrupt end under the vice-governorship of Tadayori's son,
Tadatsune, a man who has gone down in history as the sec-
ond great rebel to threaten the Fujiwara hegemony.

At the turn of the tenth century Tadatsune succeeded his
father as vice-governor of Shimōsa. Like his ancestors,
Tadatsune was dependent on the goodwill of the Fujiwara,
then still the most powerful clan of court nobles. It had been
through the kind offices of the Fujiwara that the court had
granted Tadatsune his estate, and like all young warriors, he
had learned to appreciate and yield to the power that could
effect such decisions—at least as long as that power lasted.
Already for more than a century the Fujiwara had been the
most powerful clan in the country. They had attained that
position by providing their daughters as imperial concubines
and consorts. In the wake of their womenfolk, the Fujiwara
men, too, had gained favor at the imperial court, and before
long most of the important posts of government were occu-
pied by Fujiwara nobles. Their real hold on power had been
established a century before, toward the end of the ninth
century, when Fujiwara Yoshifusa became regent to the
juvenile emperor. Yoshifusa's son, Mototsune, took this
ingenious system one step further when, on the emperor's
coming of age, he crowned himself *kanpaku*, or civil dictator.
From then on the Fujiwara *kanpaku* ruled supreme, and, as
Tadatsune's own appointment seemed to underscore, so in
his days the Fujiwara *kanpaku* ruled the country. As a young

boy, Tadatsune had grown up with the tales of the power of the Fujiwara—how the *kanpaku* Fujiwara Kanaie, so confident of the unassailability of his position that in summer he would often feel free to appear at court in no more than his undergarments. Each of Kanaie's three sons succeeded him in turn, and though his third son, Michinaga, never made it to his father's office, yet already in his day he was believed to be the greatest Fujiwara to have ever lived. True to his status, Michinaga lived on a grand scale, with vast estates, lavishly laid out mansions, and a retinue that not only rivaled but even eclipsed that of the imperial court. Far from shying away from ostentation, like most of the nobles at the Heian court, Michinaga positively reveled in all his splendor, a trait that helped inspire the great contemporary author Murasaki Shikibu to write her famous *Genji monogatari*, the *Tale of the Shining Prince*.

Though far removed from the capital and not a member of the nobility, Tadatsune knew of the ostentation of the Fujiwara, and being thoroughly schooled in the Chinese classics, he knew that such ostentation was the precursor to decadence, and that decadence was the herald of decline. Like any warrior worth his name, he also had a keen sense of the balance of power, and it was that very sense that, toward the end of the second decade of the eleventh century, told him that the balance was beginning to tilt against the Fujiwara. In 1019, Michinaga was succeeded by his son, Yorimichi, and while the latter was an able administrator, he lacked the charisma and authority with which his father and those before him had so skillfully pacified the many local

skirmishes that had threatened the authority of centralized power. The greatest threat to that authority—and thus the Fujiwara's hold on power—was the fickle disposition of the warrior chieftains, many of whom were either of Taira or Minamoto stock.

Half a century earlier the authority of the court had been tested by one such man, Taira Masakado, one of Takamochi's many offspring, who also hailed from Shimōsa. Legend has it that on one splendid autumn day in 936 he and another warrior chieftain, Fujiwara Sumitomo, had visited the capital and climbed Mount Hiei. When they reached the top and had taken in the breathtaking view of the capital in all its splendor, carried away by their sense of elevation, they vowed to seize the kingdom for themselves. During that brief but exhilarating moment, it had seemed to them that destiny had willed it so, for it seemed only natural that Masakado, as a man of imperial descent, should be crowned emperor, and that Sumitomo, as a descendant of

Taira Masakado, the first great Taira rebel to threaten the Fujiwara hegemony

7

Masakado Iwa, the place where Masakado and Sumitomo are said to have forged their unholy pact

the clan that had produced imperial regents, should become *kanpaku*.

As always, the truth was rather more complicated. The trouble had started in 930 when, eleven years after the death of Masakado's father, a dispute had arisen between Masakado and his uncle and adoptive father, Kunika, over the succession rights to Masakado's estate. The conflict came to a head five years later when Masakado came to blows with Minamoto Mamoru, the vice-governor of Hitachi and a close ally of Kunika. In that struggle all of Mamoru's three sons were killed. Bereft and outraged, Mamoru proceeded to Kyoto and denounced Masakado as an enemy of the state. Masakado was summoned to the court, but it appeared his luck had not yet run out, for shortly afterward the young emperor Suzaku came of age, and in the general amnesty that was proclaimed to celebrate the occasion, the rebel chieftain was pardoned. Yet instead of mending his ways, Masakado now banded together with a certain Fujiwara Haruaki, who

owned vast tracts of land in the province of Hitachi and was equally keen on increasing his possessions. Government troops were sent down to sort things out, but they were soon crushed by the two powerful allies. Encouraged by his success, Masakado proclaimed himself the new emperor and proceeded to invade neighboring provinces. Such was the success of his exploits that by the end of 939, he had subdued as many as eight northern provinces.

Down south, meanwhile, Fujiwara Sumitomo, the other rebel chieftain to feature in the old legend of Mount Hiei, had built up a large maritime force with which he was raiding the shores of the Inland Sea with unprecedented impunity. These developments so upset the otherwise complacent court that it finally decided to dispatch a large force of some four thousand men to quell the rebels once and for all. To ensure success it appointed as generals Taira Sadamori, Minamoto Tsunemoto, and Fujiwara Hidesato—all men who had their own scores to settle with the rebel chieftain. The

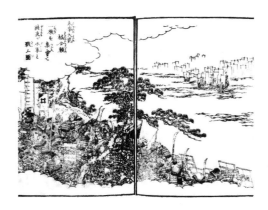

Government troops await the pirate ships of Fujiwara Sumitomo

court would not be disappointed. Before the year was out the rebel forces had been subdued. Both Masakado and Sumitomo had died in battle. Their heads were sent to the capital for inspection and to be put on display as a warning to those who contemplated following their example.

There was much in Masakado's exploits that appealed to the young and ambitious Taira Tadatsune. He knew that the official historical records depicted Masakado as a rebel, an egocentric, out to enrich himself and undermine the authority of the imperial court, but he preferred the account of events as given in the *Masakadoki*. This earliest of war tales, recorded in elevated Chinese prose by a local Buddhist monk only shortly after Masakado came to his end, firmly chose the rebel's side, portraying him as a man whose possessions had been besieged by hostile and covetous relatives, whose talents and rightful claims had gone unrecognized by an ungrateful court, and whose efforts to set things right had been sidetracked through the influence of evil and conniving men.

Tadatsune had good reason to prefer the latter version of events, for his own mother was none other than Masakado's daughter. She had raised her son on the book's moral lessons and had vouched for their veracity through her own personal and often tearful accounts of the unbearable hardships she and her siblings had suffered at the hands of Masakado's enemies. Far from feeling any shame Tadatsune proudly identified with Masakado's aspirations and dreamed of the autonomy of rule his maternal grandfather had sought to

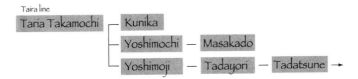

Taira line of descent from Taira Takamochi to Taira Tadatsune

achieve. That chance, he felt, came toward the end of 1027, when Fujiwara Michinaga passed away at the age of sixty-one. Though Michinaga had retired from office a decade earlier, he had continued to exert his influence and act where his son, Yorimichi, often failed to.

Betting on the court's sluggishness, Tadatsune resigned as vice-governor of Kazusa, raised a large army, and marched on the Kokufu of Kazusa. His strategy worked. Not until February of the next year had the court finally nominated the two men who would serve as *tsuitōshi*, generals of the punitive expedition for quelling the revolt. It took another four months before the Military Council began deliberations on the matter, and two more weeks until, finally on June 21, the two commanders were officially appointed. More than half a year had passed between the time Tadatsune had raised his army and the two appointed commanders were able to do the same. Moreover, fearful of giving too much power to the Minamoto, the council had appointed Taira Naokata and Nakahara Narimichi, thoroughly mediocre men. The latter took to his bed, complaining of smallpox, within days of his appointment. By then the damage had long been done. On July 13, a letter from a beleaguered governor of Kazusa

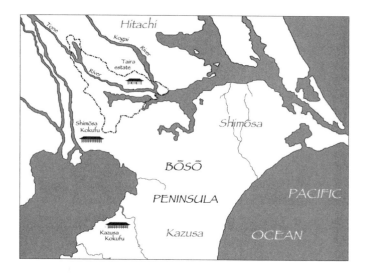

reached the capital notifying the court that Tadatsune's men had forced their way into his offices and mistreated his men, that the locals no longer responded to his orders, and that all control over the province was now in the hands of Tadatsune, who, the governor lamented, "now decides on matters of life and death with impunity."

Not until August 5, 1028, did Naokata and Narimichi depart from Kyoto. They did so at the head of an army of fewer than two hundred men. The first sign of the lack of their resolve came within only a week of their departure, when Narimichi got word that his eighty-year-old mother had taken ill. Having only reached the border of Mino, less than a hundred miles from the capital, Narimichi sent back a messenger and ordered his men to pitch camp until he had word from his mother. This set the pace and spirit in which

the rest of the expedition was executed. The same lassitude seems to have taken hold of those at the center of power, for it took the court almost a year before it seriously began to consider replacing the impotent generals. Finally, in December 1029, Naokata and Narimichi were summoned to return to the capital.

By this time, Tadatsune had firmly entrenched himself in the eastern Kantō. In the two years that had passed since he had risen in revolt, he had come to exert unprecedented leverage over its populace, extorting those who had wealth, and forcing the peasantry to raise ever more burdensome rice levies in order to support his rapidly expanding forces. These had grown so strong that, in the spring of 1030, he was able to march into Awa, the most southerly province on the Bōsō Peninsula. With no time to pack his belongings, its governor fled for the coast and made his escape over water, leaving even his seals of office behind for Tadatsune to use and abuse.

Back in the capital, meanwhile, the members of the Military Council were finally beginning to awaken to the urgency of the situation. Having discharged Naokata and Narimichi without honors, the council appointed Minamoto Yorinobu, the vice-governor of Hitachi, as the new commander to liquidate the rebel. In doing so the council members knew full well that they were using a double-edged sword, for next to the Taira, the Minamoto were one of the most powerful warrior clans of their time. As court nobles, the Fujiwara had always depended on the loyalty of the military clans to sustain their hegemony and keep the country

united. Upsetting the precarious balance of power between the two rival clans by giving so much leverage in the Kantō to the Minamoto might well lead to a military standoff, and the council realized that it was very unlikely that the eventual victor in such a standoff would be inclined to recognize either its authority or that of the Fujiwara.

The Minamoto descended from Emperor Seiwa, by reason of which they were also known as the Seiwa Genji, or "Seiwa Minamoto clan." Their founder was Minamoto Tsunemoto, the same Tsunemoto who had helped quell the rebel chieftains Masakado and Sumitomo. Those victories, as well as others, had firmly established the military reputation of the Minamoto. Like the Taira, the Minamoto chieftains were beholden to the Fujiwara *kanpaku* for their promotions, and since most of Tsunemoto's descendants were popular at court, they had rapidly climbed in rank and stature. By the time Yorinobu had made his debut at court, the Minamoto possessed large estates in Settsu, Mino, and Yamato, all home

Minamoto Tsunemoto,
founder of the Seiwa Genji

14

provinces, or provinces near the capital, which only helped to enhance their influence at court. Such was the reputation of this formidable clan that when, in the spring of 1031, Yorinobu marched into the province of Shimōsa at the head of a large force, the rebel Tadatsune dared not meet him in the field. Instead, he and his troops withdrew into the marshes in the vicinity of Katori, where they laid low in the hope that the storm would blow over.

But the storm did not blow over. Yorinobu was not the kind of man to let himself be summoned to the capital and dismissed without honors. Hiring a local guide, he penetrated deep into the marshes, cutting off all supply routes to his foe. This strategy put Tadatsune into an impossible situation. To a large extent his predicament was due to his own reckless behavior. His depredations over the previous years had devastated large tracts of the countryside. Many of the peasants and other laborers indispensable to the rural economy had fled over the borders into neighboring provinces, leaving much of the otherwise so arable Tone delta barren of harvest. As a result, his men had been poorly fed. Now, cut off and able to plunder the local granaries no longer, they were practically starving. Tadatsune's own health was also declining, a decline precipitated by a long and harsh winter spent in the field. Temperatures were already on the rise again, but as a native of Shimōsa, he knew that soon the heat and the coming rains would turn the marshes into steaming cauldrons in which it would be hard enough to stay dry and in good health let alone stand and fight. Their swords would go blunt with rust and their thick suits of armor of woven silk and bamboo,

drenched with sweat and rain, would turn into stinking robes rife with lice and mildew. Wounds would fail to heal and grow into festering sores that would lay up and consume even the toughest of warriors. It was an utterly untenable situation, and thus, only weeks after Yorinobu had crossed the border, Tadatsune, his men, and two of his sons surrendered. Yorinobu, punctilious as always in the execution of his duties, immediately dispatched a missive to the capital with word that the rebel had surrendered and that he would personally bring in the culprit for trial within the next few weeks. His victory, he later boasted, had been effected "without the beating of drums, the waving of banners, the launching of arrows, or even the tightening of bowstrings." It was a victory that confirmed the great fear and awe the Minamoto inspired among the other clans and set the warrior clan well on its way to eclipsing even the Fujiwara clan itself.

For Tadatsune it was the end of his aspirations to succeed where Masakado had failed. Afflicted by increasingly ill health, he died on his way to the capital. It was just as well that he did so, for there was little hope that he would be pardoned as Masakado had been. Like his great example Masakado, Tadatsune's head was removed and sent to the capital for inspection, but, since he had surrendered, it was not put on display but returned to his family to be interred with the remains of his ancestors.

But the Taira clan did not perish with Tadatsune. One of his sons, a young man by the name of Tsunemasa, had impressed

the leader of the Minamoto clan, and it was due to Yorinobu's influence at court that Tsunemasa and his brother, in view of their surrender and their youth, were pardoned. It was also through Yorinobu's patronage that, not long after the death of his father, and in spite of the latter's poor legacy, Tsunemasa was appointed to succeed his father as vice-governor of Kazusa. This, too, was a shrewd move of the Minamoto leader. Tsunemasa's profound indebtedness to Yorinobu for the survival of his clan meant that the Minamoto had an even stronger foothold in the Kantō, and helped to ensure that in any future conflicts he and his descendants would choose the side of the Minamoto. In 1051, for example, when Yorinobu's son, Yoriyoshi, was put in command of a large force to subdue Abe Yoritoki, a rebellious chieftain in the province of Mutsu, he was joined by Tsunemasa. It would take the seasoned warrior, who had fought alongside his father on many a campaign, twelve years to quell the unrest, and it was only with the help of thoroughly reliable allies like the Taira that he was able to do so. The same was true for Yoriyoshi's son, Yoshiie, who was dispatched to Mutsu three decades later to subdue yet another Mutsu chieftain.

For the Minamoto it must have felt that they were fighting for two causes: in quelling the various disturbances that threatened national unity, they were not only rendering distinguished service to the court but also widening their sphere of influence northward. And so, too, in a way, it was for the Taira. In return for services rendered, they attained new lands in the province of Mutsu. They were also allowed to retain their possessions in Shimōsa and Kazusa and thus

steadily widen their own sphere of influence in the Bōsō Peninsula, until, by the end of the eleventh century, their chieftain held the vice-governorship of both Kazusa and Shimōsa. By that time they had assumed the new clan name of Chiba, after the name of the new district in which they had settled and erected a large mansion, not far from where the Miyako River poured into Edo Bay.

In their prosperity the Chiba clan spread and multiplied, giving rise to new clans with new names as they did so. One line, the Hara, the large clan from which the young Yamashiro descended, settled in the district of Senda. Others settled elsewhere and took on local names: the Kaneda, the Kaburagi, the Kashima, the Shirai, and, of course, the powerful Sōma clans of Mutsu and Shimōsa. And thus, if we go back far enough, to the closing decades of the Heian period (794–1189), to the times of a man called Chiba Morotsune, the founder of the Sōma clan, and the ancestor of Nennami Okuyama Jion, or Sōma Yoshimoto, we find that there is indeed more than just

A few old gravestones mark the site where once stood the Chiba mansion

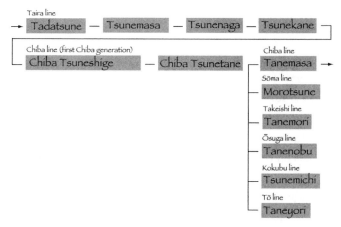

Line of descent from Taira Tadatsune to Chiba Tsunetane and his offspring

a geographical feature that connects the life of the young Iizasa Yamashiro to that other great swordsmen who spent much of his youth on the banks of the Tone River.

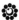

Even as a distant descendant of the house of Chiba, Yamashiro would have had much to be proud of. Its leading members had played prominent roles in almost every episode in Japanese feudal history. Chiba Tsunetane, a direct descendant of Taira Tadatsune, was the first and perhaps the greatest in this long line of warriors. He had played an active role in the final ascendancy of the military over the Heian court nobility when, in 1156, he had joined Minamoto Yoshitomo and Taira Kiyomori to quell the Hōgen Insurrection.

The Hōgen Insurrection, so named after the imperial era in which it occurred, had its origin in a succession dispute at

the imperial court. Two contenders had stood up, and both had been supported by court factions with their own political agendas. Eventually the matter seemed to have been settled when one of the contenders, Go-Shirakawa, was appointed as the new emperor. But events took an unexpected turn when Fujiwara Yorinaga, the man destined to become the new regent, was turned down as the young emperor's tutor. Outraged at being slighted, Yorinaga now chose the side of the other contender. Whereas Yorinaga had only a few troops at his disposal, Go-Shirakawa, as the lawful heir, could rely on the support of the leaders of the Taira and the Minamoto. In military terms the Hōgen Insurrection was a minor incident; it had ended when, after only one night of fighting, Yorinaga was killed and the palace to which he and his claimant had withdrawn was destroyed by fire. In political terms, however, the incident was of immense consequence, for even though Go-Shirakawa became emperor, his very reliance on the military clans had fatally undermined the power of the court. For the next seven hundred years it would be military men, and not emperors advised by their regents, who would rule Japan. In the immediate aftermath of the Hōgen Insurrection, the Taira and the Minamoto became the real contenders for political power, and for a long time it seemed that the Taira were positioned to make the best of the military ascendancy.

The many campaigns in the north had brought the Minamoto clan much wealth and prestige, but somehow they were able to translate neither their wealth nor their prestige into the level of political influence at court they had

enjoyed in the past. Instead of conferring important posts on the Minamoto, the court played down their important contributions to the stability of the state by viewing the rebellions as local affairs that were the private responsibility of the clans. Always wary of contenders for power, it even issued a decree forbidding vassals like Tsunetane to join Yoshitomo on his visits to the capital. The politically more shrewd Taira, meanwhile, cleverly used the court's jealousy to their own advantage. This, together with the waning influence of the Fujiwara, propelled their leader, Taira Kiyomori, into a position of great influence at court. The Minamoto deeply resented Kiyomori's increasing hold on power but proved incapable of operating with the same political finesse, and thus they fell back on the one faculty in which they outshone the Taira: their military genius. Their first attempt to topple the balance of political power in their favor by force came early in 1160, when they staged a palace coup while Kiyomori had gone to Kumano on a pilgrimage.

Chiba Tsunetane, greatest in a long line of Chiba chieftains

21

But Kiyomori was quick to react, and after a standoff of a few weeks, the Minamoto were successfully expelled from the capital, thus bringing to an end the Heiji Insurrection, the second open contest for power within the span of a decade. Yet the rivalry between the two clans lingered on— leading eventually to the Gempei War (1180–85), and it was in that war that Chiba Tsunetane played a crucial role in restoring the Minamoto fortunes.

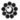

Few of the Minamoto warriors who had participated in the coup were spared. One of them was Minamoto Yoritomo. He had been only fourteen when he and his two siblings had been miraculously pardoned by Kiyomori in the wake of the coup. For twenty years he was forced to live a life in exile, relying on the hospitality of clan leaders who had been loyal to his father. One such man was Hōjō Tokimasa, whose manor was situated near the seaside town of Itō, on the Izu

Minamoto Yoritomo, the warrior who would be shogun

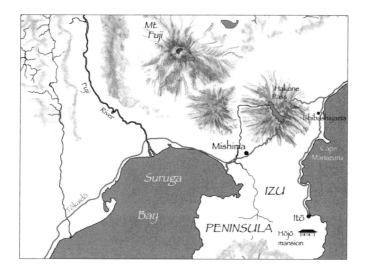

Peninsula, and it was there, in the shadow of Mount Fuji, at a safe distance from the capital, that the young Yoritomo nursed his grievances until the moment would come when he could take action.

That moment came in the summer of 1180, when Yoritomo received news from one of his spies in the capital that only a few weeks earlier Kiyomori had frustrated another coup attempt by a member of the Minamoto and that he had resolved to persecute all those who had been involved in the conspiracy. Though Yoritomo had not participated, he had been informed of the plot and knew that his life was now in grave danger. His host prudently advised him to go into hiding, but the young warrior, frustrated by yet another blemish on his family honor, decided that the time had come to show his mettle. Rallying all the local

*Ishibashiyama,
the place where
the Gempei War
began*

support he could get, he crossed Hakone Pass that same autumn and headed westward, along the Tōkaidō, the main road that skirted the Pacific coast, toward the capital. His men, though unwaveringly loyal, were few in number, and when they encountered the far more powerful, punitive force under the command of Ōba Kagechika, they were forced to seek the safety of the Hakone mountains. There, at Ishibashiyama, the first battle of the Gempei War was fought and Yoritomo suffered a crushing defeat at the hands of Kagechika's men. Yoritomo barely escaped with his life. He managed to reach Cape Manazuru, from where he and the few men who had not been killed or scattered in the fighting, embarked for Awa, the province on the southern tip of the Bōsō Peninsula.

Yoritomo had sustained a severe setback. He knew there would be more to come, but his supreme confidence in his destiny—to restore the family fortunes—remained unbroken. No sooner had he landed an the shores of Awa than he

took possession of the Kokufu of Awa. From there he sent word to his clan's allies in the region, seeking their support in the overthrow of the hated Kiyomori.

Chiba Tsunetane, that old ally of Yoritomo's father, was deeply moved by the young warrior's plight, for though he himself had not taken part in either of the two coup attempts, as an ally of the Minamoto, he too had felt the wrath of Kiyomori. All his titles had been taken away from him, while the ancient family possessions in Sōma had been confiscated by the state and awarded to his old foe and northern neighbor Satake Yoshimune, a descendant of the Hitachi line of the Seiwa Genji. Tsunetane had repeatedly applied for clemency and the return of his lands, but at each and every turn he had been frustrated in his efforts by Shimōsa's governor, Fujiwara Chikamichi. Hearing of Yoritomo's determination to topple Kiyomori, he greatly rejoiced and immediately dispatched a messenger south-ward, assuring Yoritomo of his support and advising him to set up his headquarters at Kamakura.

Encouraged by the support he had gained, Yoritomo now began to march northward, toward the Kokufu of Kazusa, reaching it on September 13, upon which he killed the governor's deputy supervisor and occupied his office. Meanwhile, Tsunetane and his men were riding southward to meet up with Yoritomo. Before he had departed from Chiba, he had sent one of his sons to Ichikawa with instructions to copy Yoritomo's example and occupy the Kokufu of Shimōsa. He had left his grandson behind in control of the family mansion, but not long after Tsunetane had

departed, a messenger informed him that the governor's son, Chikamasa, had laid siege to the family mansion, forcing Tsunetane's grandson to retreat to a nearby beachhead. Taking with him some three hundred mounted warriors, Tsunetane immediately turned back to relieve his besieged offspring and managed to capture the governor alive. By the time Tsunetane and Yoritomo finally met up at the Kokufu of Shimōsa, on September 17, all of the Bōsō Peninsula had been brought under the control of the Chiba clan. It was a great military achievement, accomplished in less than a week. That evening, Tsunetane and his six sons celebrated their victory with Yoritomo and their other allies in front of a fettered Chikamasa, the son of the man who had dared to deprive the Chiba of their family heritage in Sōma.

Two days later, Yoritomo and his allies pitched camp on the eastern banks of the Sumida River, while Tsunetane and his sons were busy assembling the many boats that were needed to ferry the men and horses across. Their plan was to march for Kamakura, as Tsunetane had advised. As yet they were only a few hundred men strong, but that evening, yet another descendant of the Taira, Chiba Hirotsune, the vice-governor of Kazusa, joined them with some several thousand men. It appeared that after twenty years in exile and his crushing defeat at Ishibashiyama, the tide had finally turned in Yoritomo's favor. That autumn he entered Kamakura at the head of a huge army. Besides Tsunetane and Hirotsune, a large number of other local warrior chieftains had joined up with Yoritomo, among them leaders of the powerful clans of Oyama, Takeda, Toyoshima, and Kawagoe.

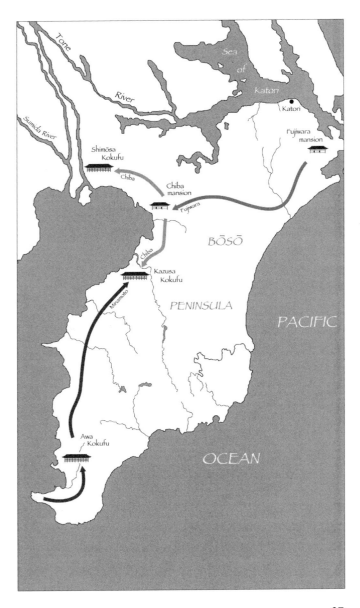

27

The first serious test of their combined strength followed not long after, when, on September 20, they faced the forces of the Taira across the Fuji River. As night began to fall and the warriors in both camps nervously counted the number of campfires on the opposite bank, a mounted scout entered the Taira camp and reported that the enemy force had grown to more than two hundred thousand mounted warriors. This led a certain Nagai Saitō Bettō Sanemori, an archer from one of the eastern provinces and familiar with the way in which the eastern warriors fought, to tell of their strength and utter fearlessness in battle. He suspected that, since the enemy was familiar with the terrain, they would probably try to encircle them from the base of Mount Fuji. Not surprisingly, such reports and speculations caused a great deal of unrest among the assembled warriors. So much so that, according to the *Heike monogatari*, that night, on the sudden ascent of a large flock of birds:

> The Taira warriors cried out "hark! the huge force of the Genji is upon us! The Genji of Kai and Shinano are encircling us from the base of Mount Fuji, just as Saitō Bettō said! There must be several hundred thousands of enemy horsemen! How can we hold out if we are surrounded? We should fall back from such a place as this and check them at Sunomata and the Owari River!" As they did so, they began to retreat en masse, each one trying to outrun the other and forgetting to collect their belongings in their haste. Such was the clamor and confusion that those who grabbed their bows knew not where to find their arrows, and those who grabbed their

arrows knew not where to find their bows, or they let others mount their own horse or mounted those of others. Some, having mounted a tethered horse, kept riding around the stakes in circles. All the while the air was filled with the profuse wailing of the harlots and prostitutes who had been called in from nearby hostels for entertainment, but were now being kicked in the head and trampled underfoot.

When Yoritomo and his followers did cross the river the following day, not a man remained in the Taira camp. All they found was the abandoned armor of the Taira warriors and the curtains of their officer's quarters. It was a most auspicious victory, causing Yoritomo to kneel toward the capital and exclaim that he could "claim no credit for what had been achieved, for it was the will of the Great Hachiman." Many more battles were to follow over the course of the next five years, and while none were won with the same ease, and some even lost, it was Yoritomo, the leader of the

The nervous Taira warriors take flight at the ascent of a flock of geese

29

Minamoto clan, who, despite the odds, eventually claimed victory over the Taira at the sea battle of Dan-no-ura.

Acting on Tsunetane's advice, Yoritomo made Kamakura the seat of feudal government. The institute by which he ruled was referred to as the Bakufu, or "tent government," a Chinese term that had originally referred to the headquarters of the Commander of the Imperial Guard. This was somewhat of a misnomer, but not one without purpose, for to give legitimacy to his dictatorship, Yoritomo was careful not to tarnish the authority of the emperor. The latter retained his throne and his symbolic position as the head of state in Kyoto, while Yoritomo had himself appointed Commander of the Right Division of the (Imperial) Guard. In reality, however, Yoritomo had become the de facto military ruler, who controlled most of the eastern provinces from his power base in Kamakura. This was confirmed in 1192, when Yoritomo was appointed *sei-i tai-shōgun*, "barbarian-subduing generalissimo," an appointment for life. After his death in

Ōji hill, former site of Ōji castle, the power base of the Chiba clan

1199, the balance of power gradually shifted to the Hōjō, who were of Taira origin, but they, too, maintained the Bakufu as their military instrument of wielding power.

Under the Kamakura Bakufu the Chiba clan reached its pinnacle of power. The currency of that power was territory. In the course of the many campaigns on which they had fought alongside the Minamoto against the forces of the Taira, the Chiba had steadily increased their already considerable possessions, with estates as far afield as Kyushu. The symbol of that power was Ōji castle, a large stronghold built along the Murata River not far from the site where the clan's founding father had laid the first stone for the Chiba mansion.

Ironically, two centuries after one member of the Chiba clan had helped found the Kamakura Bakufu, another member assisted in its overthrow. Tsunetane's descendants, in the spring of 1333, along with a great number of other warlords, responded to Nitta Yoshisada's call to arms when the latter raised his banner before the Ikushina shrine and set out for Kamakura to overthrow the Hōjō. The rebellion was started on the request of the former emperor Go-Daigo, who had been exiled to the Oki Islands for conspiring against the Bakufu in his attempt to restore power to the imperial throne. With Yoshisada's help the Hōjō were removed and Go-daigo was reinstated in his imperial palace in Kyoto, but his rule did not last. After only two years of Go-daigo's reign, Ashikaga Takauji, one of the generals who had helped him back to power, rebelled and set about

Nitta Yoshisada, indefatigable leader of the loyalist cause

building his own Bakufu headquarters in Kamakura in the image of his distant ancestors, the illustrious Minamoto. Bound by existing loyalties, the warrior clans who had united to overthrow the Hōjō broke into two camps, one led by the Nitta and the other led by the Ashikaga. During the first years of fighting the odds seemed to be in favor of the loyalists, who forced Takauji to flee across the water to the southern island of Kyushu. By the summer of 1336, however, he had recovered and, with the help of sympathetic Kyushu warlords, landed an immense fleet in the province of Bingo. From there he drove Yoshisada's forces all the way back to Kyoto. Before the year was out, Takauji had installed himself in the capital and Yoshisada had beaten a retreat westward, to the province of Echizen, where he fell in battle two years later. It was a blow from which the loyalists never recovered.

Though the cause for which Yoshisada had fought was taken up by others, none of them succeeded in evicting

Takauji from Kyoto. Yet the struggle between the two factions continued unabated. The loyalists, for their part, continued to uphold the cause of Go-Daigo, who had managed to flee the capital and establish a new court in Anō, hidden away among the Yoshino mountains, not far from Nara. Takauji, meanwhile, erected new headquarters in the capital's Muromachi district, not far from the imperial palace. So as to give legitimacy to his Muromachi Bakufu, he installed a prince of imperial descent in the palace in Kyoto, thereby turning the struggle into one between a Northern Court in Kyoto, backed by the Ashikaga (Muromachi) Bakufu, and a Southern Court in Anō, backed by the loyalists. This struggle, recorded in glorious detail in the *Taiheiki*, would last for more than half a century, until, late in 1392, the Southern Court responded to an overture by Takauji's grandson, Ashikaga Yoshimitsu. Before the year was out, both parties agreed that the two courts be unified and that the succession alternate between the two imperial lines.

Ashikaga Takauji, founder of the Muromachi Bakufu

33

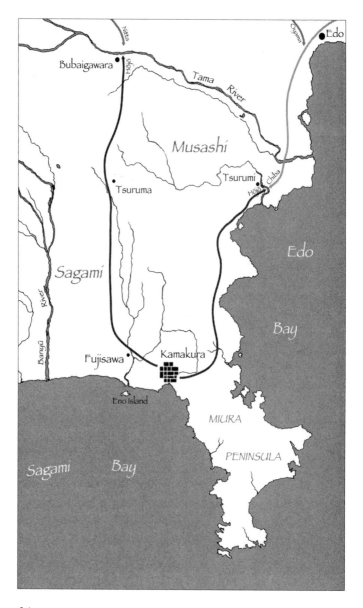

The various members of the Chiba clan had played a prominent role in these dramatic events. When, in the spring of 1333, Nitta Yoshisada had risen in revolt, the young Chiba Tanesada, Tsunetane's immediate descendant and the man destined to become the new leader of the Chiba clan, had immediately responded by raising troops. His allegiance to the Ashikaga clan had led him to join the forces of Ashikaga Takauji when the latter marched on Kyoto. His cousin, Chiba Sadatane, too, had assembled his men, and while Sadatane's commitments lay with Yoshisada, he had not marched to Ōta, the seat of the Nitta clan, but toward Edo, where he joined forces with the Hitachi loyalist Oyama Hidetomo. From there they crossed the Tama River and proceeded southward, toward Kamakura, until, on May 17, they reached the hamlet of Tsurumi, on the west bank of the Tsurumi River, where they routed a large Bakufu force under the command of Hōjō Sadamasa, the constable of Musashi.

Sadamasa's defeat came in the wake of several others. Only six days earlier, Bakufu forces under the command of Sakurada Sadakuni had been routed by Nitta Yoshisada and his allies on the plain of Kotesashi. This had been followed, on May 16, by Hōjō Yasuie's defeat at Bubaigawara. That defeat, suffered after two days of intense fighting on the banks of the strategically situated Tama River, had crushed the resolve of the Bakufu soldiers to such an extent that Yasuie was forced to fall back toward Kamakura. Yoshisada pursued his foe along the Higher Kamakura Road, which followed a more inland route, through the province of Sagami, toward Fujisawa. Meanwhile, following their victory

*Hōjō Takatoki
and his followers
in Kamakura's
burning Tōshō
monastery*

at Tsurumi, Chiba Sadatane and his ally had driven Sadamasa and his men back along the Lower Kamakura Road, which skirted the coast of Edo Bay, through the province of Musashi. Both forces converged on the capital at roughly the same time, but, due to their different routes, at opposing sides. It was a decisive move, for the Bakufu forces were now held as in a vice, with no way of escape. For five days the Hōjō managed to hold out against Yoshisada's forces, but on the fifth day, on July 5, 1333, the regent, Hōjō Takatoki, seeing that he was fighting a losing battle, ordered his men to set fire to the Bakufu buildings. That same day, Takatoki, thirty-four of his family members, and some two hundred and eighty of their retainers withdrew to the Tōshō monastery and committed suicide en masse.

Following Ashikaga Takauji's revolt, the Chiba clan had, like so many other clans, inevitably been rent asunder. Due to existing ties of loyalty, Sadatane had continued to fight on the side of Yoshisada and the loyalists, while Tanesada had

joined the forces of the Bakufu. What made the rivalry between the two cousins all the more ferocious was that one year after they had contributed to the overthrow of the Kamakura Bakufu, both scions of the Chiba clan became the players in an internal succession dispute.

As Tsunetane's direct descendant, Tanesada had been the man destined to become the clan's new chieftain. But it was not to be. The reason for this change of fortune lay in the dramatic changes that had been taking place on the Asian mainland during the middle of the previous century. There the Mongols were on the rise. By 1264, they had forced the Sung court to retreat to the south and made Beijing the new capital. The Kamakura Bakufu had continued to maintain relations with the Southern Sung but was exceedingly wary of Kublai Khan, who was rapidly expanding his empire not only westward but also eastward, into the Korean Peninsula. This wariness was not unfounded, for only four years later envoys arrived at the Bakufu's southern headquarters at Dazaifu with a letter from the Great Khan demanding that the Japanese submit to his rule unconditionally or face invasion. The Bakufu leaders flatly refused to compromise Japanese sovereignty and sent the envoys packing, nor did they fail to act. They immediately increased the coastal defense forces on the western shores of Kyushu, where they expected the Mongol fleet to land. Then, in 1271, warned by a Korean missive that the Mongols were preparing to invade, they ordered all clans who owned land on the southern island

of Kyushu to post their forces on their territories and pre-
pare for the pending Mongol invasion.

One of the many rewards the Chiba had received in return
for having fought so many long and hard campaigns with the
Minamoto was a small estate called Ogi. It so happened that
the Ogi estate lay on the island of Kyushu, in the western
province of Hizen, one of the two provinces where the
Mongol attack was expected, and thus Tanesada's grandfa-
ther, Yoritane, had ridden south with his men to take part
in the defense of their estate and their country.

When, in the autumn of 1274, the Mongols finally landed,
it soon transpired that in spite of their efforts, the Japanese
were ill prepared for the onslaught. Many of the defenses
that had been built were only makeshift and not sturdy
enough to withstand the heavy missiles and combustibles

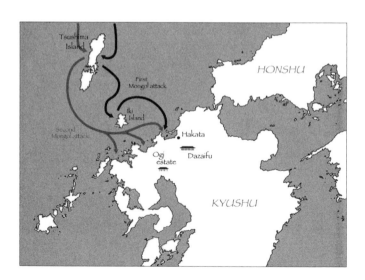

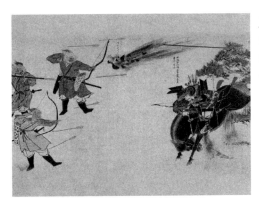

Japanese warriors come under attack by Mongols

the Mongols fired from their engines. It was only with superhuman effort and the timely help of a fierce typhoon that the Japanese warriors managed to expel the Mongols from their shores. Never in its history had their country come so close to being invaded and hard lessons had been learned. One of them was the need for a defensive wall that could withstand the heavy missiles. Another was the profound difference in the way in which the two peoples fought. In sharp contrast to the Japanese warriors, who were used to man-to-man combat, the soldiers of the Mongol forces fought in tight formations. They also had powerful crossbows, able to inflict lethal wounds at a far greater distance. Yoritane was one of the first to feel the effectiveness of this new weapon when, in the heat of battle, he was hit by an arrow. The injury itself was not serious, but that night he fell into a fever that led his men to believe that the arrow had been poisoned. For several days he lingered, plagued by incessant fevers and convulsions that hurled him between

39

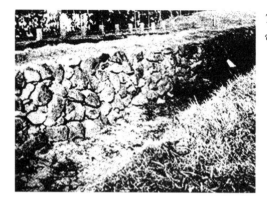

*The stone defense
wall at Hakata*

life and death, until his organs finally gave out and he expired. He was only thirty-six.

Yoritane was succeeded by his son, Munetane, who, like his father, was not allowed to return to Shimōsa. Already within months of the invasion, news had reached Kamakura that the Mongols were preparing a second, even larger, invasion, prompting the Bakufu to order its vassals to remain in Kyushu and prepare for the attack. They set to work on constructing a high defensive wall along the Bay of Hakata, facing the beachhead where they had suffered the brunt of the first Mongol attack.

The second attack came in the summer of 1281, when a fleet of several thousand ships, manned by close to one hundred thousand men, landed at Hirado, Imari, and Hakata. This time the Japanese were better prepared, and for two months they managed to repel attack after attack without giving away much territory. Yet once again it was the elements that saved the day for the valiant warriors. On the

40

fifteenth and sixteenth of August a violent typhoon hit the shores of Kyushu with full force, scattering the fragile vessels of the Mongol fleet and forcing the invaders to retreat. They had suffered a devastating blow. As many as thirty thousand of their men were either killed in flight or consumed by the towering waves. The remainder fled back to the mainland, beaten and unwilling ever to set foot on Japanese soil again. The wind that had brought this miraculous rescue was henceforth known in the Japanese annals as the Kamikaze, the Divine Wind.

Munetane did live to tell the tale, but like his father, he was never to see his homeland of Shimōsa again. And again following his father's fate, he died young, in 1294, only thirty years of age. At this time, Tanesada was still a young child, and since he was being raised in Kyushu, the elders of the clan back in Shimōsa had decided to temporarily confer the leadership of the clan to the shoulders of the deceased's brother, Tanemune. Following his coming of age, Tanesada

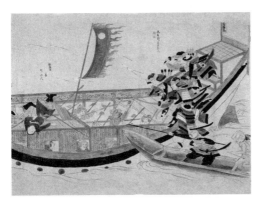

Japanese warriors pursue the Mongols into their ships

41

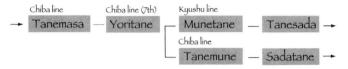

Line of descent from Chiba Tanemasa, through Chiba Yoritane, to Chiba Tanesada and Chiba Sadatane, the two great rivals for clan leadership

was allowed to leave Kyushu for Kamakura to serve the Bakufu. Not long afterward, he was joined by his younger cousin, Sadatane, who had been raised at Inohana castle, the new stronghold on the family estate in Chiba. For several years the two men seemed to get on well, but that changed in 1312, when the old Tanemune passed away and the clan's elders decided to simply pass the leadership down to his son, Sadatane, instead of returning it to Tanesada, the man who represented the family's main line of descent. For many years Tanesada could do little else than grudgingly accept his lot. All that changed in 1334, however, when, through an odd quirk of fate, the two young and equally ambitious men found themselves on the opposite sides of the battlefield.

During the first two years of the struggle between the two courts, the two cousins were too involved in the greater military campaigns to be able to address their private differences, but in 1336, after the forces of the Bakufu had evicted the loyalists—and his rival cousin—from the capital, Tanesada saw his chance to regain control over the family estates. That same autumn, he joined forces with his distant

The redoubtable stronghold of Inohana castle

relative Sōma Chikatane, another Bakufu ally, and marched toward Shimōsa in an attempt to regain Inohana castle and the de facto leadership of the Chiba clan. But the newly completed and impenetrable castle was well defended, and what had been intended as a quickly executed family coup turned into a long, drawn-out siege.

Sadatane, meanwhile, was coming to terms with his own setbacks, for the elation that had accompanied the overthrow of the Hōjō had long since gone. For two years he had fought hard on the side of the loyalists, but the fruits they had reaped were bitter. They had won many victories but were farther than ever from winning the war. And though they had not been crushed in the second great battle for the capital, they had sustained a blow from which they seemed unlikely to recover. The capital, which had been under their control for more than a year, was back in the hands of the Bakufu, while the emperor had been forced to flee into exile. They themselves were also forced to seek safety, but

43

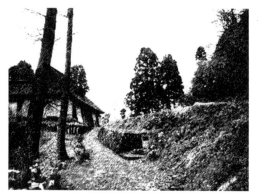

Ki no Me pass

even in retreat Yoshisada and his followers were being hounded like quarry. The *Taiheiki* recounts how, on October 11, 1336, shortly after they had been forced to relinquish the capital:

> Yoshisada with some seven thousand mounted warriors arrived at Shiodzu in the district of Kaizu, but hearing a rumor that the constable of Echizen, Shiba Takatsune, had blocked the mountain pass some seven and a half *ri* from where they were, they chose a different road and traversed the Ki no Me pass. In the high mountains of these northern countries, snow usually began to fall at the beginning of October, but that year the cold had set in early and the blustering snow that fell thick and fast onto the mountain road soon reached up to the men's waists, causing the soldiers to lose their way, and, as there were no hostels along the mountain roads, they were forced to sleep under trees or huddle up in the shelter of the rocks. The Kawano, Doi, and

Tokunō rearguard of three hundred mounted warriors had lost their way and made battle with the enemy north of Shiodzu, but both the horses and the soldiers were paralysed by the cold and all died by taking their own lives. Chiba Sadatane had also advanced with some five hundred mounted warriors, but had wandered off the road amid the falling snow and, as they had strayed right into the enemy camp, they gathered together and made ready to take their own lives, but persuaded by Takatsune they reluctantly surrendered, upon which they were drafted into Takatsune's forces.

It seems hard to explain the relative ease with which this battle-hardened warrior submitted to the Bakufu. It was true that there had been no real disgrace in Sadatane's act; he had realized that there was "death both in advance and retreat," and his decision to spare his men was an almost gracious act. But as always there was more than just the fate of his men on the warrior's mind. In a world of constant flux, in which warlords change sides or throw away their lives for far less worthier reasons, his first loyalty was to the prosperity of his clan. It had been only two years since the leadership of the Chiba clan had been conferred on him by a string of happy coincidences. But that cold October day, as he and his battle-weary men plodded through the deep snow on the Ki no Me pass, it must have seemed to him that that same fate had conspired to wrest the Chiba leadership from him again with that same fickle ease. Shortly after he had joined Yoshisada on that dismal journey, news had reached him that his cousin had laid siege to the family stronghold of

Inohana castle. Unable to break the siege himself, he realized that it was only a matter of time before Tanesada would subdue Inohana castle. It may well have been his preoccupation with his cousin's activities back in Chiba that caused the warrior to let first his mind and then his horse wander from the course that he had set himself in his obligations to the loyalists. By thus defecting to the side of the Bakufu, Sadatane had created a chance, however small, of regaining the Chiba leadership that had been dropped in his lap a decade before.

The chance turned out to be far bigger than he had expected, for it was somewhere along the Tōkaidō that his cousin, who had been appointed to escort him to Kamakura, fell seriously ill and died. With his cousin's death, Sadatane's position was ensured, for not long afterward he was officially recognized as the new Chiba chieftain and appointed as the constable for the Bakufu in Shimōsa.

And thus, once again, in spite of the change of power at the center, the Chiba clan was able to continue to prosper. Tanesada's son, Tanetaka, settled in the district of Senda and founded the Senda lineage of the Hara clan, and thus was the

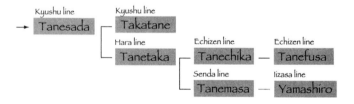

The Hara line of descent from Chiba Tanesada to Iizasa Yamashiro

direct ancestor of our story's hero, Iizasa Yamashiro. There can be little doubt that, with so many illustrious forebears to look up to, the weight of family honor must have felt heavy on the small shoulders of the infant warrior Yamashiro.

If we are to believe the family records of the Iizasa clan, Yamashiro was born in the fourth year of the Genchū era, 1387. This presents the first incongruity in the swordsman's history, for the same records claim that he died in the second year of Chōkyō, which is 1488. In modern-day Japan, where people regularly celebrate their centenary, reaching the age of 102 is not considered a great feat, but in Yamashiro's day it would have been a feat of near-mythical proportions. Other records claim that he was born sometime during the Ōei period. This is far more likely, since that period ran from 1394 to 1427, which brings his span of life well within a century. Given that in his day and age one could consider oneself fortunate to reach the age of sixty, it is most likely that Yamashiro was born somewhere during the second or third decade of the fifteenth century.

Iizasa Yamashiro grew up in a time of peace. By the time he was born, the Northern and Southern courts had been reunited for several decades and the Muromachi Bakufu ruled supreme. Yet even though the Bakufu had reached the height of its power, Japan was by no means a fully pacified country. Even after the last remnants of the loyalist forces had been wiped out in Kyushu, insubordinate warlords in all parts of the country continued to undermine the

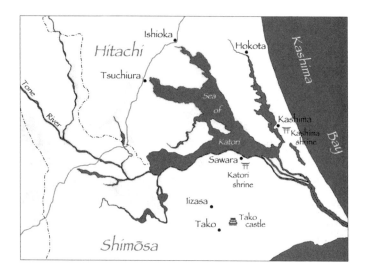

authority of the Bakufu, so that hardly a year went by without the shogun having to dispatch a force to subdue some greedy warlord seeking to add part of his neighbor's territory to his own. Compared to the vast and protracted campaigns of the previous century, which spanned the length and breadth of the country, the conflicts during the first decades of the fifteenth century were largely local affairs and limited in scale. They hardly ever lasted more than a few weeks, so that even when they did erupt, they affected few except the protagonists involved. While at times inconvenienced by all these skirmishes, farmers, artisans, and commoners could generally retire from their day's work in the knowledge that, by the time they rose the next morning, the fruit of their labors would not be wiped out by some marauding gang of starved warriors. The great distances

that the Bakufu forces had to travel in order to reach their destinations, combined with the general discipline with which these expeditions were executed, often formed a positive stimulus for the country's economy. On the whole, the first few decades of the fifteenth century were a time of recuperation and growth.

Things were changing for the better, then, during the first decades of Yamashiro's life, and for the better in his family. Its men and women worked the lands around their modest estate in Iizasa, and after every harvest they dutifully paid their tax in rice yield to their master, Enjō Terauji, who ruled the Senda district on behalf of the Chiba clan. The Enjō had their headquarters at Shima castle, which stood in the neighboring village of Tako. Unlike the Iizasa, they were not direct descendants of the Chiba, yet like them they could rank themselves among their most trusted vassals. Terauji was the most senior counselor of the clan's current chieftain, Chiba Tanenao, who had succeeded to the leadership of the clan upon the death of his father. That was in 1430, only a few years after Yamashiro was born.

For the young Yamashiro and his family, Chiba Tanenao was a man to look up to. He was the fourteenth chieftain of the Chiba clan, the direct descendant of the great Sadatane, and the Bakufu constable in the provinces of Kazusa and Shimōsa. Tanenao had been only twelve years of age at his appointment, but in spite of his youth he proved a thoughtful and able ruler. He refrained from any extortionist practices and was a patron of the famous shrine of Katori, situated in the village of Sawara on the banks of the Tone River.

49

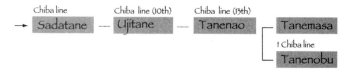

Line of descent from Chiba Sadatane to Chiba Tanenao and his two sons

And it was early in his reign that Tanenao undertook the large-scale reconstruction of the shrine and its many out-buildings. Yamashiro's father, too, played his part in these activities, for as the chieftain of the Iizasa clan, and like all other chieftains who owed allegiance to Tanenao, he was expected to bear his part of the burden in maintaining the shrine that was so closely associated with the history of the Chiba clan.

The shrine of Katori was one of two famous shrines in the region. The other was the shrine of Kashima in the village of the same name, some ten miles northeast of Sawara across the border with Hitachi. In Yamashiro's day the two villages were separated by a wide expanse of open water called the Sea of Katori. Fed by the Tone River, the Sea of Katori was part of an even larger complex of lakes and marshes that extended northward to the village of Hokota and westward to the village of Tsuchiura. Together with the shrines of Ise, Heian, and Kasuga, the shrines of Katori and Kashima were among the oldest and most prominent in the country, and their religious role in the lives of his contemporaries cannot be overestimated. They were the larger nodes in a vast net-

work of shrines throughout the country and part of an institution of immense cumulative wealth that, both on its own and through the patronage of the military clans, wielded considerable political power. The older and larger shrines especially possessed huge estates that were worked by members of the so-called *kanbe*, groups of local families that were directly attached to the shrines. Taxes were levied on the yields of the lands they worked to finance the huge costs associated with the operation and maintenance of the shrines. Thus, the shrine of Katori alone kept close to a hundred men occupied in a large number of capacities divided over as many as twenty grades of seniority.

The importance assigned to the shrines of Katori and Kashima was—and still is—firmly rooted in Shinto mythology and the creation myth of Japan. Much of that mythology is recorded in the *Kojiki*, the *Record of Ancient Matters*, and the *Nihon shoki*, the *Chronicles of Japan*, the two earliest extant histories of Japan. Both were compiled at the beginning of

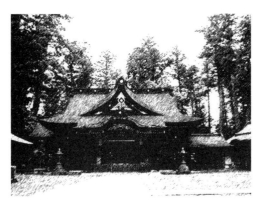

The Katori shrine, patronized by the Chiba and Iizasa clans

the eighth century, at the behest of Emperor Tenmu, largely with a view to giving legitimacy to the imperial dynasty. They relate in elaborate and often confusing detail the genesis of the Japanese islands, the foundation of the imperial line, and the history of the Yamato empire until the year 701. Involved in, and often the cause of, these birth pangs was a vast pantheon of gods, the so-called *kami*. At their head were the god Izanagi and the goddess Izanami, the heavenly couple whose union resulted in the birth of the Japanese islands, the seas around, and all that was in them. Yet the newly created realm was not a peaceful one, for apart from giving birth to the land and its environs, Izanami also gave birth to a large number of gods and goddesses who turned their attention to less-loving activities. There must have been much of the medieval warlord about them, for their main pastime was to create disorder and confusion. The Sun Goddess Amaterasu Ō-Mikami's calling was to subdue her fellow deities and create order on earth. In this she

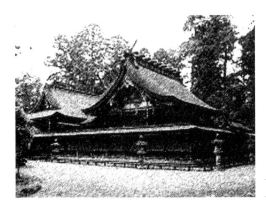

Rear view of the Katori shrine

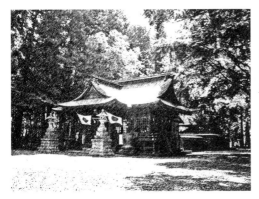

The Kashima shrine, birthplace of the Kashima Shintō school of fencing

was constantly thwarted, until the two martial deities Futsunushi and Takemikazuchi came to her aid and the country of Yamato was finally pacified.

Such myths were still deeply believed in Yamashiro's time, and in all the events that shaped their daily lives, large or small, the people still recognized the hands of their gods. Their spirits were believed to reside in the shrines, thousands of which had been erected over the centuries—on remote islets, on solitary capes and mountaintops, and at the foot of cascading waterfalls. Given the powers of their occupants, the shrines, too, became objects of veneration and none was too remote or inaccessible for devout pilgrims to come and pay their respects, whether in rain or snow, in order to appease the particular god that held sway over their clan.

It so happened that the shrines of Katori and Kashima were associated with the deities of Futsunushi no Kami and Takemikazuchi no Kami respectively. Given their martial symbolism, both deities had been the guardian deities of

53

great military clans such as the Fujiwara. The shrines in turn were patronized by the military clans, a tradition that was still very much alive in Yamashiro's day. As a result of the close association with these military clans, the many *matsuri*, or Shinto festivals, honoring the war gods Futsunushi and Takemikazuchi that were held at the two shrines became deeply infused with military symbolism and laden with martial rituals. And while they were first and foremost a testimony of the people's deep-seated veneration of the deities themselves and a festive recognition of their godly powers, at the same time they were a confirmation of the worldly power of the military. They were a glorious display of male and military prowess, a blatant manifestation of the rule of might, an unabashed celebration of the proud traditions of their martial code. For all those who participated in their intoxicating splendor by helping to carry the portable Shinto shrine, or *mikoshi*, the festivals were a ceremonial reminder, a ritual and material reaffirmation that the land

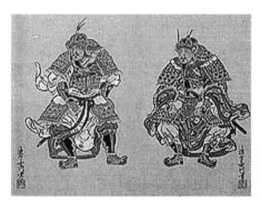

Takemikazuchi (left) and Futsunushi

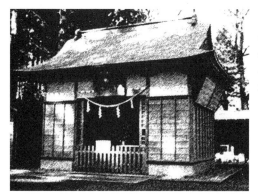

The buiding at the Kashima shrine that houses the mikoshi

and its people were inseparably bound together in a mythological past and none other than the gods themselves had preordained the ascendancy of the military and sanctioned the legitimacy of its rule.

In time, the shrines themselves became the repositories of the military customs and traditions typical of the clans by which they were patronized. From old the clans had recorded for posterity the methods and techniques by which they had acquired their positions of power. Originally they had been a crude set of notions and techniques, passed on to the next generation by word of mouth. Over time and with each generation, they evolved and matured into a highly complex and often deeply esoteric system of teachings that, while they continued to draw on old family traditions, began to incorporate wider martial beliefs and practices, from, for example, Chinese works on philosophy, divination, and military tactics. One such teaching was the *heihō*, or art of warfare, a system that focused on the strategic and intellectual

55

aspects of warfare at the level of those who conducted armies. Another and closely related system was that of *budō*, the martial arts, which was concerned mainly with the techniques and other technical aspects of the art of warfare at the individual level of the warrior. Originally such teachings had, for obvious reasons, been the intellectual property solely of the clans. They were fiercely guarded and passed on through a strict line of carefully selected teachers. Even in peacetime, those who were found to be in breach of a clan's martial code—which put loyalty to the clan before everything else—by divulging any of its secrets, or *okugi*, to a rival clan could expect little mercy. As time wore on and as the involvement between the clans and the two shrines deepened, these martial techniques were gradually assimilated by the shrines. Distinct schools of fencing evolved that were no longer the property of a specific clan but were directly identified with the shrines at which they were practiced. Eventually they were even named after the two shrines, the Katori Shintō-ryū and the Kashima Shintō-ryū.

As with so many warriors, Yamashiro's first contact with the martial arts was through his father, for it was from his father that the young warrior learned to wear and draw his sword. And while Yamashiro enjoyed a childhood largely untrammeled by the ravages of civil war, from a very early age, under the watchful eyes of his father, he absorbed the martial traditions and ethics that the preceding period of conflict had brought forth. Yamashiro was a highly intelligent child who

quickly absorbed what was put before him. So much, at least, is borne out by the records of the time, which mention how "already at a very young age he displayed a great fondness for the arts of fighting with the spear and the sword, in which he was very deft."

Inevitably, the greatest influence on the budding swordsman was the school of fencing associated with the shrine of Katori. Whenever he visited the shrine with his father, he would marvel at the accomplishment of the swordsmen who practiced their techniques on its grounds. By the time he had reached the age when he could join them, there were a few men in particular to whom he looked up for mental and technical guidance. These were the so-called *hafuribe*, a group of men who were carefully selected from the ranks of the *kanbe* to serve as shrine officials. In that capacity, the *hafuribe* were ultimately responsible for the unsullied continuation of their shrine's particular fencing style. In Yamashiro's day, the *hafuribe* were renowned for

A hafuribe *of the Katori shrine wielding a traditional* yari, *or lance*

their mastery of the sword, and they jealously guarded their *okugi*. Clan members could still be initiated into these *okugi*, but it was the *hafuribe* who were heir to the secrets simply by birthright.

During the long years of reconstruction, Yamashiro spent much of his time on and around the premises of the shrine of Katori, and it must have been almost as a second nature that he absorbed the martial rituals and techniques that were performed and practiced by the *hafuribe*. Indeed, more than anything else, it was the Katori Shintō school of fencing with which the young Yamashiro grew up and that so profoundly shaped the style he developed later in his life. Even now, some six hundred years later, the story is told of how, as a young lad, he was often seen passing through one of the shrine's many gates, clutching in his small fists his inseparable *bokutō*, or wooden sword, to practice his latest fencing technique on the plum trees that stood on a small hill in the shrine's precincts.

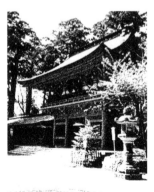

The rōmon, *the impressive two-storied main gate of the Katori shrine*

Even today one can embark by boat from Sawara in the traditional way

But the Katori Shintō-ryū was not the only school that had come to influence Yamashiro's style of fencing. During the summer months, when the weather was fair, the young boy often joined his father when he embarked from Sawara by boat and crossed the Sea of Katori to the village of Kashima. There they would visit the shrine of Kashima, and while his father discharged the errand on which he had come, the young Yamashiro would observe and later join the shrine's *hafuribe* as they practiced the techniques of the Kashima Shintō school of fencing. The *hafuribe* of the Kashima shrine were all members of the Urabe, one of the oldest *kanbe* lineages. Like the *hafuribe* of the Katori shrine, the Urabe were the main carriers of the fencing style associated with the Kashima shrine. According to the somewhat mythical family records of this ancient family, their style of fencing went all the way back to the fourth century, to a man named Kuninatsu Mahito, who lived during the reign of Emperor Nintoku. Mahito was said to have developed the

59

Traditional Japanese sailing boats on the Sea of Katori

Shinpyō-ken, an art of fencing that had been transmitted down the generations by the Urabe under the name of Kashima no Daitō. By Yamashiro's time it had divided into two major schools, the Kashima Jōko-ryū and the Kashima Chūko-ryū. As Yamashiro grew older he would often make the ten-mile walk to the village of Sawara and cross the Sea of Katori by himself to make offerings on behalf of his family at the Kashima shrine, and to practice and improve his fencing skills with the practitioners of the two Kashima schools of fencing.

All seemed to be set, then, by the time Yamashiro reached manhood for him to follow in his father's footsteps and take his turn in governing the family estate, to dedicate himself to the maintenance of the Katori shrine, and to pass on to the next generation the ancient art of the Katori Shintō style of fencing. But it was not to be, for far away from the peaceful bliss of the Iizasa estate, the quiet forests around the Katori shrine, and the beautiful Sea of Katori,

dark clouds were gathering over the capital. Soon those dark clouds of discontent would spread and release their sullen load over the unsuspecting populace of Senda.

Since the reunification of the Southern and Northern courts the Muromachi Bakufu had ruled supreme. One strong shogun had succeeded another, and most had been capable politicians as well as shrewd tacticians. They had consolidated their power base by keeping on good terms with the reunited imperial court and had taken a conciliatory approach toward the great warrior clans that had once opposed them. This delicate balance of power was upset, however, when, in 1428, on the death of the shogun Ashikaga Yoshimochi, the reins of power were handed over to Yoshinori, then the chief abbot of the Tendai sect. Yoshinori turned out to be an erratic and belligerent man wholly lacking the diplomatic skills of his predecessors.

The erratic and belligerent Ashikaga Yoshinori

61

Within only months of his appointment, he was at logger-
heads with some of the most powerful clans in the country,
clans such as the Uesugi in the east and the Ōuchi and
Ōtomo in the west. For a time Yoshinori's methods of brute
force and ruthless suppression seemed to work, but as his
power grew, so did the number of his enemies. The reward
for his reign of terror came in 1441, when he was invited to
a banquet and murdered by one of his generals. Yoshinori
was succeeded by his son, Yoshikatsu. But the boy had a frail
constitution and died within months of having been
appointed shogun. Yoshikatsu was succeeded by Yoshimasa,
who became the eighth shogun of the Muromachi Bakufu,
and it was during his reign that the linchpins in the once so
sturdy power structure of the Muromachi Bakufu became
thoroughly and irrevocably dislodged.

Much has been written about Yoshimasa and the aesthetic
niceties of his court. He was responsible for the construction
of some of the capital's most beautiful buildings. The small-

*The famous and
exquisite Silver
Pavilion*

*Ashikaga Yoshimasa, founder
of the Higashiyama Culture
but incompetent ruler*

est yet most delightful among them is undoubtedly the
famous Silver Pavilion, set among the scenic splendor of
Higashiyama, just east of the capital. Yet the price for these
products of what came to be known as the Higashiyama
Culture was heavy, for where Yoshimasa excelled in the
sphere of the senses he was utterly devoid of any leadership
qualities whatsoever. As if this was not bad enough, he was
also happily free of any sense of responsibility, of any moral
qualms, and utterly oblivious to the grave and irreversible con-
sequences of his actions and—more often—the lack of them.
With every year of his reign, the Bakufu grew weaker and his
court increasingly prone to decadence and corruption.

A telling sign of Yoshimasa's incompetence and the con-
spiracy of the Bakufu generals in the country's social and
political disintegration was the many *tokusei* that were issued
during his term in office. These so-called virtuous acts of
government, or debt cancellations, predated the feudal
period. They had first been issued in the ninth century by a

Heian court that was conducting a vast campaign against the Ainu, Japan's original settlers, and sought to offer the general populace some relief from the burdens of war by cancelling outstanding taxes and private loans. They had been revived in the thirteenth century under the Kamakura Bakufu, but already then to disastrous effect, for no longer were they meant to recompense a highly burdened populace. Instead, they were used to protect the warrior class (the foundation of the Bakufu's hold on power) from an increasingly powerful mercantile class during a time of economic revival. It was for the same selfish reason that Yoshimasa's advisers chose to dust off the *tokusei*, only to meet with the same hostility from the commoners, the hardworking artisans and merchants who had supplied the military clans with their goods and credits. Yoshimasa singularly failed to learn from the mistakes of his predecessors, nor did he have the presence of mind to take note of the great disturbance his pampering of the military class caused among the populace. Indeed, it seemed that it merely stimulated him to continue on his stubborn course, for no fewer than thirteen *tokusei* were issued during his time in office.

The reaction of the populace was commensurate. Within the same year that the first *tokusei* was promulgated, farmers rose in revolt in Fushimi, Saga, Toba, Ninnaji, Kamo, and Miidera. They demanded a debt relief similar to that granted to the military clans. They were soon joined by commoners from the environs of Kyoto, who marched upon the capital in the thousands and occupied houses and monasteries along the capital's western outskirts. These riots, or *ikki*, were put

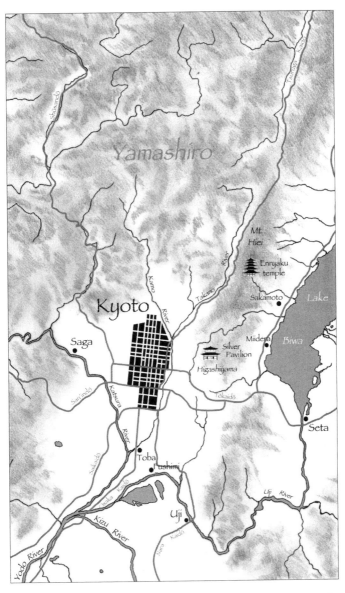

down by force, but they were not the first, and over the following years, as the general resentment with Bakufu policies grew, many more followed. To add to the misery of the commoners, huge storms destroyed the rice crop of 1457, resulting in widespread famine and plagues that lasted for three terrible years. Some eighty thousand people died within the first two months of that year in the capital alone, causing the whole city to become permeated with the stench of the many corpses that clogged the Kamo River.

In the very midst of these calamities, both man-made and natural, Yoshimasa took up a plan to build a palace of Flowers where he could indulge his pastimes without having to confront the grim reality around him. He even built a new palace for his mother, Shigeko, simply because she had been distressed at not having been allowed entry into the fragrant gardens of the Saihō monastery in an effort to escape the stench. The shogun's leading generals, instead of seizing control, chose to ignore the ever worsening plight of the

The Kamo River at night still evokes former days

The idyllic gardens of the Saihō monastery

Bakufu. They had been away from the battlefield for too long to care, and many of them had come under the spell of the court, where influence was not gained through decisive action but through intrigue, slander, and flattery.

It was only a matter of time before the rottenness at the core of the Bakufu organs of power would cause it to lose its grip on the Kantō warriors. Since the founding of the Muromachi Bakufu, the eastern provinces had been governed by the *kantō kubō*, who held office in Kamakura. This office went all the way back to 1335, when Ashikaga Takauji had appointed his son, Motouji, as governor in Kamakura before he set out along the Tōkaidō to meet Nitta Yoshisada's forces. At the time, the Uesugi was the most powerful clan in the Kantō area, and it had been from its ranks that the Bakufu drew men to assist the *kantō kubō* as deputies. The relationship had soured in 1415, however,

67

Uesugi Norizane, the second deputy to fall out of grace with the kantō kubō

when the governor, Ashikaga Mochiuji, an unbalanced and violent man, forced his deputy, Uesugi Ujinori, to give up his post over a trifling affair. Rightfully outraged, Ujinori had risen in revolt. For a time he had even held Kamakura in his control, but when the Bakufu sent troops to assist Mochiuji, Ujinori was forced to commit suicide.

This was not the end of the troubles between the *kantō kubō* and his deputy, for a similar conflict arose in 1438, when Mochiuji fell out with Ujinori's successor, Uesugi Norizane. The latter, however, had learned from his predecessor's mistake and had anticipated Mochiuji's wrath. He made a timely withdrawal to Hirai castle, on his clan's estate in Kōzuke, where he lay low in the hope that the storm would blow over. But it did not. Incensed at his deputy's insubordination, Mochiuji ordered the chieftains of the neighboring provinces to mobilize their armies and march on Hirai castle to punish Norizane. But the chieftains were not keen to comply with the *kantō kubō*'s request. They knew that the

Bakufu had long lost its patience with Mochiuji's tantrums. Chiba Tanenao, whose mother was Ujinori's daughter, even went out of his way to visit Mochiuji with one of Norizane's intermediaries in an attempt to salvage the situation, but to no avail. The Bakufu in Kyoto, meanwhile, had also sent out orders to their constables in the Kantō, but not to chastise the deputy rather the *kantō kubō* himself.

Thus it was that, in the autumn of 1438, Chiba Tanenao found himself marching on Kamakura under the command of the Bakufu general Miura Tokitaka in order to subdue a recalcitrant *kantō kubō*. Only a few of the local chieftains had come to the aid of Mochiuji, and all of them were defeated within a few days of fighting. Mochiuji was apprehended and allowed to take the tonsure and enter the Eian temple to await the Bakufu's verdict. For two months the warrior-turned-monk clung on to dear life, until, on February 10, 1439, and in spite of Norizane's request for clemency, the Bakufu passed sentence that the *kantō kubō* should commit

A clearing in a bamboo grove is all that remains of the Eian temple

ritual suicide. It was left to the twenty-year-old Tanenao, who had guarded the former *kantō kubō* during those two long and awkward months, to convey this message to the by now broken-spirited monk.

Few of those who had participated in Mochiuji's demise were happy with his death, least of all Tanenao. It was not the kind of end befitting a man who had held such high office, nor did it spell much good for the authority of the office itself. Indeed, for the next ten years the post of *kantō kubō* remained vacant. During that period de facto control over the Kantō was exercised by the deputy, or *kantō kanrei*, but it was not a happy arrangement, as many of the local chieftains resented the powerful position into which the Uesugi had been propelled.

For a time it seemed that this source of discontent had been amicably resolved, when, in 1449, and partly on Tanenao's request, the Bakufu accepted the nomination of Mochiuji's one surviving son, Ashikaga Shigeuji, as the new *kantō kubō*. Yet too much of Mochiuji's blood must have flowed in the young man's veins, for like his father, Shigeuji turned out to be a belligerent man, bent on revenge against the Uesugi, the clan whose deputies had been unloyal to his father. At the time, their leader and sitting *kantō kanrei* was Uesugi Noritada, and it was against Noritada that the new *kantō kubō* turned his wrath. No sooner had he been appointed than he began conspiring against his own deputy. By this time the Uesugi had grown so powerful that when Noritada got wind of the plot against him, he simply dispatched two of his vassals to Kamakura in order to deal with

Enoshima, once the island refuge of a revengeful kantō kubō

his scheming superior. It was a telling reversal of power, for this time it was the *kantō kubō* and not his deputy who was forced to seek safety elsewhere. Shigeuji barely escaped with his life. He fled Kamakura and took refuge on the nearby island of Enoshima, off the Izumi coast. Again rescue came through the intervention of loyal constables such as Tanenao, but despite their repeated attempts at reconciliation, even from his island he continued to conspire against the man who had been appointed as his deputy.

Four years later, in the winter of 1454, Shigeuji finally succeeded in his misguided quest for satisfaction by assassinating his deputy, Uesugi Noritada. The Bakufu duly sent its troops down to punish its most senior representative in the Kantō for the second time in two decades. Chiba Tanenao, too, was ordered to mobilize his men and join the Uesugi in their march on Kamakura. Their troops never reached their destination, however. Many of the local chieftains who feared the growing power of the Uesugi had chosen to take

the side of Shigeuji. Their combined forces confronted those of the Uesugi on the banks of the Kamo River and dealt them a stunning blow. Two of the Uesugi commanders incurred such grave wounds that they were unable to withdraw and were forced to commit suicide. The remainder of their army was only able to save their skins by making a forced retreat, all the way to the province of Hitachi, where they ensconced themselves in Oguri castle. Yet even there it was only with great difficulty that they were able to hold out against Shigeuji's men, their fate dependent on the speedy arrival of reinforcements from Kyoto.

Chiba Tanenao, meanwhile, had managed to retreat to his stronghold in Chiba. By this time he had come to thoroughly curse the day he had supported the nomination of Shigeuji as the new *kantō kubō*. He had done so with the hope of restoring the Bakufu supremacy in the Kantō, but it had all gone horribly wrong. Not only had Shigeuji sorely abused his office, like his father before him, but by crushing the Uesugi, he had also seriously jeopardized the feeble stability in the Kantō region. It seemed that in doing so he had removed the last hold the Bakufu exerted over the many unruly Kantō warriors. Tanenao knew that sooner rather than later, the dire effects of this disastrous development would have their inevitable repercussions on the stability in the very provinces under his own control.

How very soon became painfully clear to Tanenao early in February 1455, when news reached Inohana castle that a

large force was being mobilized at the nearby castle of Oyumi. Though Tanenao had anticipated trouble, he was nevertheless taken off guard by the news, for the master of Oyumi castle was none other than Hara Tanefusa, one of his most loyal vassals. Tanefusa was the chieftain of the Hara, a clan directly descended from the Chiba. Indeed, all of the other strands of the Hara clan, including the Iizasa, were completely taken aback by Tanefusa's unprovoked attack. Up until then the leaders of the Hara clan had served the Chiba in a number of capacities, in which they had generally proven capable and loyal vassals. To the young Tanenao, the betrayal came as a double shock, since, on the death of the former Chiba chieftain, Tanefusa had temporarily taken over the reins of control. For close to a decade he had acted as Tanenao's regent, until early in the 1440s, when the latter had finally come of age, and Tanefusa had acquitted himself well in that capacity. Nothing in Tanefusa's conduct had given the young chieftain the impression that he bore any grudges toward the Chiba, and he had come to look up to him as his own father.

As he cast his mind back in search of an explanation, Tanenao slowly began to understand what might have led his once so trusted vassal to such a treacherous course of action. He knew that during his regency, Tanefusa had often been at loggerheads with Enjō Terauji, another trusted adviser of the Chiba clan, who owned large tracts of land in the Senda district. It had been the right to these possessions that had been at stake, and though the issue had never come to a head, it had remained unresolved.

73

Tanenao also realized that, in his capacity as regent, Tanefusa had spent a lot of time at the offices of the *kantō kubō*. As he took stock of the forces that were arrayed against him, Tanenao began see what had driven the former regent to betray his own master. It was all too likely that the regent would have raised the land dispute with the *kantō kubō*, and with what Tanenao knew of the latter's scheming and deceitful nature, he could only conclude that, in his own power play with the Uesugi, Shigeuji must have persuaded Tanefusa to join his anti-Bakufu coalition. In a crude way, Tanefusa's motives were understandable enough—they had their own callous and selfish logic. By attacking his former master, he would indirectly deal a considerable blow to the Uesugi, a clan to which the Chiba were closely allied through Tanenao's mother. In return, Shigeuji would, once his position was secure, undoubtedly grant the disputed land to Tanefusa. As yet, however, the *kantō kubō*'s position was not yet secure, for the Uesugi were still holding out at Oguri castle, and reinforcements from Kyoto might arrive at any moment. Nor, indeed, was Tanenao's own cause a lost one yet.

Tanenao's position was, however, an exceedingly precarious one. He had been prepared for an assault sooner or later, but not from such close quarters. As a result, he had been unable to mobilize his kinsmen, who were scattered over a large number of castles throughout the two provinces. To make matters worse, it soon appeared that one of them, Makuwari Yasutane, had banded together with the rebel regent, for not long after Tanefusa's forces

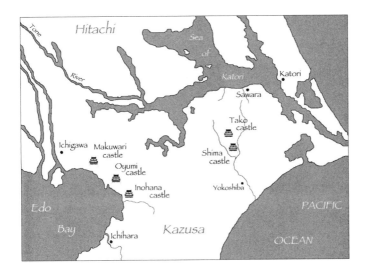

had laid siege to Inohana castle, they were joined by those of Yasutane. It became clear that the rebels were not intent on taking captives, when, on one night in May, they ordered their archers to fire incendiary arrows into the castle's exposed wooden framework. There had been no rain over the preceding weeks and before long the flames were creeping up the dry woodwork. Unable to extinguish the fire from within, and with all of his men as yet unharmed and in fighting spirit, Tanenao ordered his men to prepare for a breakout. He had resolved to make a last stand at Shima and Tako castles, both strongholds of Enjō Terauji, lord of the Senda district. If reinforcements from the Uesugi failed to reach them there in time, and if Tanefusa was to have the land he so coveted, he would have to claim it over the dead body of his former lord.

The old approach road to Inohana castle

The escape from Inohana castle was executed with great success. There were few casualties, and since the Makuwari forces were unfamiliar with the terrain, Tanenao, his son, Tanenobu, and most of his men managed to get a good head start and reach the safety of the two castles by dawn unscathed. There Tanenao divided his troops into two contingents. One he placed under the command of his son, whom he had entrusted with the defense of Tako castle. With the other he withdrew to Shima castle to await the onslaught that must inevitably come.

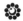

Tanenao's had been a strategically prudent move. Enjō Terauji was his most trusted vassal, whose long-standing rivalry with Tanefusa ensured that he and his men would fight twice as hard to keep their land out of the hands of their hated enemy. Though the Senda district consisted to a large part of flat terrain, with little natural protection, the two cas-

tles were strategically situated in that they stood on elevated land, only a stone's throw away from each other, and at the confluence of the Takohashi and Kuriyama rivers. Both were sturdy defenses, and in order to subdue them the rebels would have to divide their forces. Moreover, much of the terrain surrounding the village of Tako consisted of rice paddies, soft and marshy wetlands, unsuitable for the troops to set up camp and even less suitable for man-to-man fighting. Tanefusa's men would be forced to camp on higher ground, at a considerable distance from the castles and on the other side of the two rivers. Terauji and his men, by contrast, knew this terrain like no other—a knowledge that would enable them to harass the opposing forces under cover of night.

One man with an intimate knowledge of the area was the young Iizasa Yamashiro. The small estate of Iizasa lay only

Today, only the two elevations on which Tako and Shima stood remain

a mile northwest of Tako and Shima castles, and Yamashiro had spent much of his youth fishing in the nearby river's shallows and exploring the narrow tracts of solid ground amid the wet and marshy landscape. As soon as the news reached their village that the Chiba chieftain and his son were on their way, Yamashiro, his father, and the other adult males of the Iizasa clan had put on their armor, grabbed their swords, and converged on Tako and Shima castles to assist in their defense. There they were joined by a large number of other warriors from the surrounding villages who owed allegiance to the Chiba overlord. Only their fighting skills, acquired and honed on the precincts of the shrine of Katori, and their effective use of the area's natural defenses enabled the Chiba forces to hold out as long as they did. For more than a month they kept harassing the rebel forces, inflicting considerable casualties in the darkness of night or under cover of the morning marshland mists. Yet all of them knew that ultimately they were fighting a losing battle, as

their chief supply routes had been cut off and their troops were inferior in number. In the end their only hope lay in the arrival of reinforcements from the Uesugi in Hitachi, and it was this hope that was finally crushed toward the end of April when news reached the besieged men that Oguri castle had fallen.

For four more desperate months Tanenao and his men held out against the rebel forces, until, on a hot summer day in August, a lone and emaciated figure could be seen walking from Tako castle to the camp of Hara Tanefusa. It was a messenger carrying a letter from Chiba Tanenobu in which the latter offered to surrender the castle on the condition that all its inhabitants be spared and that he be allowed to commit ritual suicide. Permission was granted and that day the fifteen-year-old warrior, the seventeenth generation of the Chiba line and Tanenao's only remaining son, took his life in front of the castle's Buddhist altar. Two days later, on the evening of August 14, Tanenao followed his son's example in

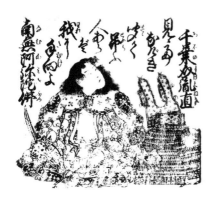

Chiba Tanenao, ready to commit ritual suicide

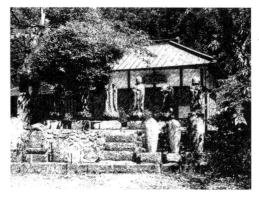

The Tōzen temple, resting place of the last scions of the Chiba line

the small Buddhist temple on the grounds of Shima castle. With the deaths of Tanenao and his son, the long line of direct descent that had begun more than three centuries before when Chiba Tsunetane's father, Taira Tsuneshige, had taken up residence on the Chiba estate and assumed the Chiba name had come to a tragic end. The remains of Tanenao and his son were buried on the grounds of the Tōzen temple, where they remain today.

Yamashiro and his father survived the fall of the two castles, but because of their support for the Chiba, they and the rest of their clan were driven from their estate in Iizasa. Their lands, and all the other possessions that had belonged to Enjō Terauji, were confiscated by Tanefusa. Homeless and without a lord to serve, the Iizasa turned to the one place where they could expect to find refuge, the shrine of Katori. There they found shelter and food for the next months,

hoping that sooner or later help might still come from the Bakufu in Kyoto.

Meanwhile, the once prosperous province of Shimōsa was being consumed by the flames of warfare, for even though the rebels had managed to subdue the two Senda strongholds, elsewhere resistance to their reign continued unabated. Tanenao's brother, Tanekatsu, had managed to escape and reach the village of Yokoshiba, but he was hounded by the rebels and forced to commit suicide. His two sons, however, reached the safety of Ichikawa castle, from where they continued to oppose and harass the troops of the illegitimate rulers.

While all this was going on, a punitive expedition under the command of the Bakufu general Tō Tsuneyori finally reached Shima castle, from which Tanefusa now controlled his illegitimately acquired Senda domains. Tō's forces were soon strengthened by local chieftains who deplored the way in which the last Chiba chieftain had come to his end.

Tō Tsuneyori, the Bakufu general who restored peace in Shimōsa province

Within days, Tanefusa was evicted from Shima castle and forced to retreat westward, to Makuwari castle, the headquarters of his ally, Makuwari Yasutane. Yet there, too, they were besieged by the Bakufu forces, and after two days of fighting, the two rebels had to withdraw once more, this time to Inohana castle, the headquarters of their former master. Early in 1456, their situation seemed to improve when, following his victory over the Uesugi, Shigeuji sent down a large force against the two surviving Chiba warriors, who were still holding out at Ichikawa castle. Seizing their chance, the rebels joined these forces and, on January 19, together they managed to bring down Ichikawa castle. The two Chiba warriors were able to safely escape, but only by fleeing across the border with Musashi to the safety of Ishihama castle, a stronghold of the Uesugi. It was the rebels' only moment of glory in a long and sordid campaign of self-enrichment. During the rest of that year, their forces were constantly driven onto the defensive by the Bakufu

A few elevations in a forest are all that remain of Ichikawa castle

forces. Yasutane's moment of reckoning came on November 1 of that year when, in a fierce battle on the outskirts of Icihara village, he was killed and his forces obliterated. Tanefusa managed to hold out for several more years in Inohana castle, but most of the province had by then been brought back under Bakufu control, and his dreams of territorial expansion had come to an ignominious end.

Iizasa Yamashiro had played an active part in much of the fighting. Following the arrival of the Bakufu troops, he had joined them in their campaigns against the rebel forces, and he had been amply rewarded. In recognition of their valiant services, the Iizasa were granted a small estate in Chōji along the southern banks of the Tone River, on the eastern periphery of Sawara. There Yamashiro and his father began work on the erection of a small stronghold,

83

*Steps leading up
to the elevation
on which
once stood
Yamazaki castle*

which, when completed a few years later, they gave the name of Yamazaki castle. Yamashiro was appointed head of the local Kebiishi Dokoro. Established during the early Heian period, this powerful imperial office had been charged with the responsibilities of policing and justice. At first it had only held jurisdiction over the capital, but as the powers of the office grew, branch offices had been erected in the provinces and, through their imperial connections, also at the shrines of Ise and Katori.

The next few years were years of relative peace for the Iizasa clan. Most of the surrounding districts had been pacified, and in comparison with the tough campaigns in the field the policing of a rural area was more of a sinecure. Yet they were also deeply uncertain times—times in which the fragile fabric of peace could be torn to shreds by the slightest dispute. In such times it was the might of the sword that counted,

and only those who had mastered its secrets stood a chance of exercising their will. It was vital, then, for those charged with the maintenance of peace to constantly hone their skills, and for this purpose the Iizasa built a large *dōjō*, or training hall, on the grounds of the Yamazaki estate. Here Yamashiro and his father spent much of their time in the practice and transmission to the next generation of the Katori Shintō school of fencing.

As their names indicate, the styles of fencing that were practiced at the Katori and Kashima shrines were intimately connected to the Shinto tradition, and the practices and teachings of each style of fencing were deeply influenced by the rituals and tradition of each shrine. Through their long association with the shrines, the techniques of these schools of fencing had become somewhat detached from the immediate requirements of the battlefield and had, despite their undiminished lethal nature, attained a more ceremonial and in certain instances even choreographic quality. For the

A few remaining rocks stand for the once formidable bulwark of Yamazaki castle

85

hafuribe, after all, the art of fencing was not an aim in itself. To them it was merely one of the many, albeit more powerful, attributes of an immensely rich Shinto tradition. If anything, for them the wielding of a sword was a physical counterpoint to the spiritual demands of their profession. Its lethal properties in man-to-man combat, by consequence, were not so much seen as a means to power but rather as direct proof of the integrity and inherent truth of the laws of the Shinto mythology.

Yamashiro had learned the hard way that many of the movements and techniques he had learned from the *hafuribe* had lost their effectiveness on the field of battle. There, the opponent wore armor instead of ceremonial robes, and instead of wielding a *bokutō*, they too were armed with one or two swords. Such conditions required, above all, that one be faster than one's opponent and use the split second one was granted to the utmost—a forceful thrust at the throat or a decisive cut at an exposed armpit or heel. Building on that experience, he did away with much of the superfluous movements in the old and staid techniques, honing movements that had proven too complicated in the heat of battle down to the type of lean and effective technique that could save a man's life rather than impress an audience. As a result of his and his father's efforts, the Katori Shintō-ryū underwent something of a revolution, shedding much of its ceremonial heritage in exchange for an unsurpassed lethal effectiveness.

However important, Yamashiro's policing tasks as a *kebi-ishi*, or police commissioner, cannot alone explain the passion and dedication with which he continued to pursue his

A small Shinto shrine hidden among the trees of the Katori forest

study of the art of swordsmanship. It is almost as if some premonition—some awareness of his martial destiny—drove him toward ever greater excellence. In that drive he spent many an hour in quiet meditation at the nearby shrine. And it was during such a session, somewhere in his early forties, that Yamashiro had his first spiritual experience. The records relate how, having spent three years in intense training and devout prayer to the deities of the two shrines, Yamashiro underwent a kind of martial enlightenment. The swordsman would later claim that in that moment of divine inspiration, the *okugi* of the Katori Shintō school of swordsmanship had been transmitted to him by none other than Futsunushi no Kami.

As it turned out, Yamashiro's premonitions were not unfounded, for early in 1467 he was called upon to go up to the capital to serve in the shogunal guard. Through the close connections the shrine of Katori enjoyed with the shogunal court, his reputation as a master swordsman had reached the

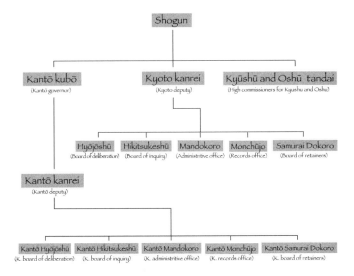

Hierarchical structure of the Muromachi Bakufu

ear of the *shoshidai*, the deputy governor in charge of the Samurai Dokoro, the Board of Retainers. Established in 1180 by Minamoto Yoritomo to control the activities of his vassals, the Samurai Dokoro had gone through a number of transformations during its three hundred years of existence. By Yamashiro's time, it had lost most of its political powers to the *Kyōto kanrei*. Instead, it had taken on other functions, such as policing, which had hitherto been performed by the Kebiishi Dokoro. It was Yamashiro's services for the Katori branch of that same office that qualified him to serve with the shogunal guard.

It was not surprising that the relief armies from Kyoto had failed to reach the northern provinces in time to relieve the besieged Uesugi forces in Oguri castle. Nor was it surprising that the shogun had to draw his guards from the very quarters he had let down so dismally. By now his office was in serious decline, and, as so often, that decline went hand in hand with the moral corruption of its officers. The worst depredations could be observed at the imperial court, the symbol of the state's unity. The terrible contrast between the decadence of the court and the unspeakable suffering of the very people it was supposed to govern could be observed right on the capital's streets. These had become a veritable stage on which both parties played out their pantomime of decay in spite of themselves, an act unfit for any stage, and a most graphic parody of the degree to which the Bakufu court had lost touch with its subjects.

One of its hapless spectators was the Zen priest Unsen Taikyoku, who, on the evening of April 9, 1460, recorded in his diary how, on his return from an errand earlier that day, he had encountered a group of noblemen only moments after he had sought to console an old woman—one of the thousands of refugees from the country—after she had collapsed in the street, clutching in her withered arms the lifeless remains of a grandchild for whom she had hoped to find some nourishment in the capital:

> The noblemen acted as if they were so superior that no one could touch them. Some of them jeered at the people in the streets; others abused the commoners who

crossed the path of their horses; others plucked cherry
blossoms; others, again, drew their swords as they sang
merrily, while others failed to hold down their food and
drink and collapsed in the gutter, unable to stand on
their two feet.

The endless suffering, amplified by the complete indiffer-
ence of the ruling classes, eroded the morale of the people,
disintegrating the very fabric of society until it had become
an empty husk ready to combust at the faintest spark.

Dramatic changes were required to turn this ever worsen-
ing state of affairs around, and in a military society those
changes were bound to be of a military nature. For while the
Bakufu generals were ingratiating themselves at court, the
leaders of the great military clans throughout Japan began to
build up their armies and prepare for war. A number of them
formed alliances to resist the Bakufu's central control.
Others, reflecting the gradual disintegration of the Bakufu
hegemony, fell back into their old ways and began bickering
among themselves, often over trifling issues. Almost all of
them fell victim to an equally old and perhaps even more
pernicious feudal evil, succession disputes. Freed by the
Bakufu's waning influence over their clan's internal affairs,
clan members seized their chance and began to contest the
appointment of successors. In a society where any clan
leader might have more than a dozen potential heirs, such
disputes were common enough. Usually they were fought
out between the oldest among them. If there was no clear
winner, the clan might be split and its possessions divided
between the two contestants, either by settlement but more

often by contest. A new phenomenon made itself felt as clan members who did not carry the leader's blood in their veins, and even mere vassals, began to claim their moral right to the family estate. Before long, these divisions ran so deep and spread so wide that hardly an estate was left that was not affected in some way or other by these internal disputes. Sooner or later these disputes were bound to escalate into full-fledged conflagrations that would ignite the ready kindling as if it had been caught in a firestorm.

At this stage everything hung in the balance; all could still be decided by a single act, a token that by its very example could either turn things around and induce the true heirs to reclaim their rights or give credence to the spurious claims of a misguided minority. Such an unmistakable sign came in 1464, when, rather than face up to his grave responsibilities, the thirty-year-old Yoshimasa set the worst possible example by preparing to resign from office, unleashing a succession dispute within the very Bakufu itself.

For at least two of the powerful clans the succession dispute within the Bakufu proved to be veritable grist for their mill. These were the Hosokawa and Yamana clans. Their leaders were Hosokawa Katsumoto and Yamana Mochitoyo. Katsumoto was perhaps the more gifted leader of the two. He was a skillful administrator who served the Bakufu in the position of shogunal deputy, as his ancestors had done before him. In that capacity, he advised Yoshimasa to appoint his younger brother, Yoshimi, then chief abbot of the Jōdo monastery, to assist him in the execution of his duties. Having thus become acquainted with the burdens of

*Hosokawa Katsumoto,
the skillful administrator
who would be regent*

the office, Yoshimi could succeed Yoshimasa by the time
the latter decided to step down. Katsumoto's was a reason-
able proposition that soon won the approval of the shogun,
but it was also a self-serving one, as he intended to rule by
proxy, through the shogun, in the same way the Fujiwara
regents of the Heian court had ruled through the emperor.
Yamana Mochitoyo, by contrast, even though he was
Katsumoto's father-in-law, did not enjoy the trust of the
shogun. He was a jealous and ambitious man, who had
gained a reputation for his uncontrolled fits of rage. He had
long been waiting for an opportunity to weaken the hold
over the shogunal court by his son-in-law. That opportunity
presented itself when not long after Yoshimasa had
announced he wished to step down, his wife, Tomiko, gave
birth to a son, who was named Yoshihisa. A scheming wife
who had amassed a fortune by resorting to corruption and
graft, Tomiko was incensed by Yoshimasa's refusal to recog-
nize his natural son as the new heir and thus deny her even

more leverage over the affairs of state. She, too, resented Katsumoto's influence at the shogun's court, and it did not take long before she and Mochitoyo found a common cause.

Furnished as if by providence with his own protégé, Mochitoyo immediately set about rallying support. By the end of 1466 his forces had grown to eighty thousand, only a few thousand fewer than those of Katsumoto. He now needed a ploy to mobilize his troops in the vicinity of the capital—a pretext to openly challenge Katsumoto's forces.

That pretext was found in yet another succession dispute, this time within the Hatakeyama clan. It was an important dispute, for the clan's leader held the powerful position of *Kyōto kanrei*, the Bakufu's deputy in the capital. It also curiously mirrored the dispute within the shogunal family. Having reached old age, Hatakeyama Mochiyuki had failed to produce a male heir. He had therefore adopted his nephew, Masanaga, to succeed him. By the time he retired, however, one of his concubines had given birth to a son,

The ambitious and intensely jealous Yamana Mochitoyo

Hatakeyama Yoshinari, contender for clan leadership

Yoshinari. The boy soon became the apple of his father's eye. So much so that when, in 1450, Mochiyuki eventually decided to retire, he sought to make his real son the head of the family, and thus *Kyōto kanrei*, in spite of his earlier promises to his adopted son. The matter seemed settled when, four years later, Mochiyuki secured the shogun's sanction, but Masanaga refused to back down and persisted in his claim, a claim in which he came to feel justified when, not long afterward, the shogun took a sudden dislike to Yoshinari and reneged on his earlier pronouncement. Serious fighting broke out between the two factions, and though after some time it abated, the embers of hostility failed to die. They continued to smolder right through the following decade, until, in 1464, they erupted into flame on the very streets of the capital.

It so happened that in this particular dispute Hosokawa Katsumoto had backed Masanaga, even though the shogun had backed Yoshinari. Egged on by Tomiko, the jealous

Mochitoyo approached Yoshimasa early in January 1467 to point out that by backing Masanaga, Katsumoto had in effect committed an act of insubordination. Sensing the shogun's displeasure, Mochitoyo asked permission to punish Katsumoto and restore honor to the shogunate. Yoshimasa, for once alert to the consequences of Mochitoyo's involvement and always preferring inaction above action, ordered Mochitoyo not to interfere in the Hatakeyama dispute but to let the two rivals fight it out between themselves. That same day he sent a missive to Katsumoto to the same effect. Katsumoto duly withdrew his support from Masanaga, but sensing that the missive was the result of Mochitoyo and Tomiko's scheming, he prepared for war. Frustrated by the shogun's refusal to contribute to his scheme, Mochitoyo, too, prepared for war and assembled a large number of his troops around the Bakufu headquarters; yet, unlike Katsumoto, he also went against the shogun's wishes by secretly sending assistance to Yoshinari.

It was February 1467, and a highly explosive mood now hung over the capital. The very air seemed charged with fear and foreboding as its citizens hid indoors while on its streets the two contenders for the Hatakeyama leadership openly fought out their differences in fierce yet erratic skirmishes. Each move, each development, was closely watched by the real contenders for power, Katsumoto and Mochitoyo, both spoiling for a fight, yet both loath to make the first move. The only thing that caused either to refrain from launching the first assault was the fear of being branded a rebel by the emperor, a stigma that was sure to lose them valuable allies.

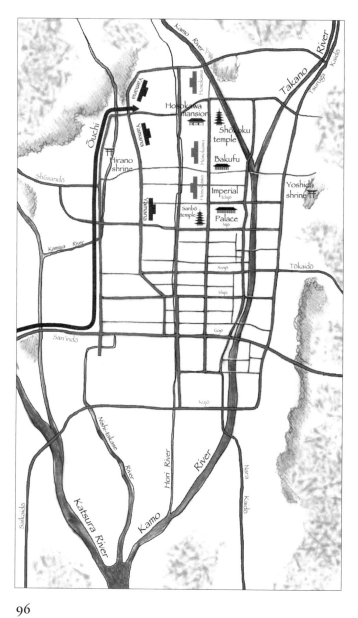

And thus they stood back, each hoping that the other would make the first move. Meanwhile, the capital's populace looked on with bated breath, hoping and praying that they would be spared the horrors their parents and grandparents had endured.

It was in this atmosphere of imminent disaster and pending doom that Iizasa Yamashiro arrived in the capital. For the swordsman from the provinces it must have been a humbling and at the same time proud moment. Kamakura was probably the largest town he had ever visited, and to see the capital at the height of its medieval glory, with its wide avenues, countless temples, and imposing palaces must have made a deep impression. Little did the swordsman know on his arrival that the next ten years of his life were to coincide with the most destructive and bloody episodes in the capital's long and checkered history.

At first it seemed the citizens' prayers had been answered when, with the help of the Yamana troops, Yoshinari won the leadership of the Hatakeyama clan and thus the office of *Kyōto kanrei*. But when, early in April, the Bakufu generals were invited to the shogun's palace to celebrate the annual spring festival, Katsumoto and his followers stayed away. Mochitoyo's treacherous support of Yoshinari had convinced him that a political settlement was out of reach. And thus both parties continued to strengthen their positions. As if to warn the capital's citizens of the inflammatory state of affairs, fires raged throughout the city's outskirts as both

parties continued to move troops into the capital. Taking heed, the citizens once more fled to the countryside. The Yamana forces were concentrated to the west, the Hosokawa forces to the east of Muromachi, a dispersion by which the two opposing forces became known as the Western Army and the Eastern Army. Then, at the end of May, Hosokawa troops attacked the mansion of one of Mochitoyo's leading generals. Within days the fighting spread to other parts of the city and soon not a day passed without heavy fighting. By June large parts of the city had been destroyed by fire, either as a direct result of the fighting or simply set ablaze by robbers in search of loot.

For five long and dreadful months the fighting continued without pause. In one respect the Eastern Army held the crown jewels. They had positioned themselves in a small area that included the Bakufu buildings and the Imperial Palace. Yet, although Katsumoto had taken the initiative and had started out with the largest number of troops at his

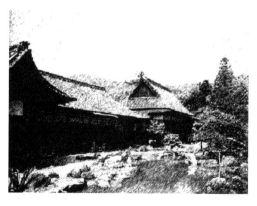

Gardens of the Sanbō monastery

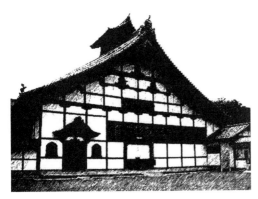

The now fully restored Shōkoku temple

disposal, Mochitoyo's forces set the tone throughout. In part this was the result of the positions the two armies had taken, for the Western Army had the tactical advantage, as they controlled no fewer than six of the city's seven approaches. Their vital importance was brought home to Katsumoto in September, when Ōuchi Masahiro, the constable of Suō, reached the capital's outskirts with some twenty thousand men and was able to join the Western Army unhindered. That same month Mochitoyo launched a massive assault on the Sanbō monastery, one of Katsumoto's strongholds, which stood close to the Imperial Palace. It went up in flames and Katsumoto's troops were forced to fall back and relinquish the Imperial Palace. The climax in this incendiary battle came on November 1, when Mochitoyo decided to attack the Shōkoku temple. Founded by none other than Ashikaga Takauji himself, this Zen temple was of strategic importance to the Bakufu, as it was situated closest to its headquarters. A priest was bribed

to start a fire inside the monastery, while Mochitoyo's troops were waiting to attack at sight of the first plumes of smoke. The ruse worked. Like the Sanbō monastery, the Shōkoku temple went up in flames and before long Katsumoto's men had to relinquish the Bakufu headquarters too. Fighting continued until late in the evening. When the remainder of both armies withdrew, the streets were littered with hundreds and hundreds of the dead.

The fight for the Shōkoku temple was the last major battle that shook the capital; the five months of incessant fighting had utterly drained the strength of all those involved. The conflict would drag on for another ten years, but at this point all spirit had gone out of the fighting. Apart from the occasional flare-ups, the dramatic troop movements of the opening months, with their massive charges and counter-charges, had vanished as if overnight. Instead, the conflict took on the character of trench warfare, in which both parties faced each other from behind a vast and intricate network of trenches and barricades. It was a truly bizarre state of affairs in which, between the occasional sorties into enemy territory by a few fanatics, the remaining troops sought to while away the time by indulging in fancy-dress parties and composing poetry.

The Ōnin War (1467–77), so named after the era with which it coincided, ended just as unpredictably as it had started. When, upon the sudden deaths of both Katsumoto and Mochitoyo in 1477, both armies evaporated with the same ease as they had materialized. When the troops had finally poured away along the capital's seven approaches, all

that remained of the once glorious capital was a sprawling ruin of charred remains. In the first few months of fighting flames had consumed hundreds of buildings. By the time the conflict had ended, only a few of the capital's major buildings were left standing. One of them was the Nijō Palace, which had functioned as the headquarters of the Western Army. But even this building was not spared in the end.

To blame for all this destruction were the *ashigaru*, or foot soldiers. Though the *ashigaru* had played their destructive role in earlier conflicts, they really came into their own during the Ōnin War, in which the cramped fighting made mounted combat useless. Drawn from the likes of renegade peasants, robbers, and other outcasts, the *ashigaru* had little respect for the few conventions that had hitherto regulated armed conflicts. Looting, kidnapping, and rape were some of the outrages they inflicted on the hapless citizenry. They usually carried a *yari*, but their favorite weapon was fire. As if to underscore the callous role they had played throughout

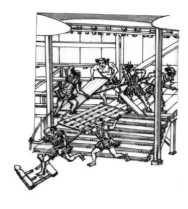

The notorious ashigaru *at work during the dark years of the Ōnin War*

the conflict and would play over the next hundred years, they committed their final act of wanton destruction on the very day of their departure by setting fire to the building that had offered them shelter and left it burning. It was the last and perhaps most potent reminder of the utter futility of war, especially this war.

When the capital was at last left to its inhabitants, little remained for them to build upon. Vast tracts of the city lay utterly bare, with only here and there a group of charred stumps. Only their symmetric arrangement reminded the solitary passerby that once they had been the site of an imposing temple or ancient monastery. Even the streets had vanished. The only way to distinguish its once so splendid avenues from the wasteland was by way of the deep scars that had effaced them, trenches that in some places ran as deep as ten feet and as wide as twenty.

Sadly, there are no records to inform us of Yamashiro's precise activities during these dark years. Given his position as an officer in the shogunal guard, it is almost certain that during the first years of the conflict Yamashiro saw action repeatedly on the side of the Eastern Army. Only weeks into the conflict, after all, Yoshimasa had sided with Katsumoto in spite of the latter's act of insubordination. He had even gone as far as to appoint him commanding general of the Bakufu forces. Consequently, the resources available to the shogun would have been employed to assist the Hosokawa forces, especially during the tense few months when the

fighting focused on the buildings closest to the Imperial Palace. After the two armies had withdrawn, the Samurai Dokoro had its hands more than full in subduing the marauding bands that had installed themselves in the few large buildings that remained standing. Such a state of lawlessness existed that even in broad daylight these marauders would swarm out across the charred ruins to terrorize the long-suffering citizenry and strip them of the few possessions they had miraculously managed to hang on to through the preceding decade. Even the remaining temples and shrines were not sacred to these new and lawless occupants. Where once the muted and regular morning call of their great bells had set the pace for a life of peace and tranquillity, now the shrill and sudden peels with which they were stirred into motion, day or night, sent shivers down the spines of all who dwelled within their reach, as if to warn them that even the gods had forsaken them.

While its effects on the capital were destructive enough, for the country as a whole the Ōnin War was the final step on the long descent into full-blown civil war. In the ten years that it lasted, a terrible wave of anarchy emanated from the capital's desolate heart. It swept through its suburbs and beyond into the countryside, until, by the end of the seventies, the whole country seemed engulfed in flames. This fire was stirred by Hosokawa Katsumoto, who had seen his position severely compromised at the outset of the conflict by the arrival of Ōuchi Masahiro's forces. But he managed to turn this great movement of troops and the vacuum it had created to his advantage. He sent numerous emissaries into

The verdant shore of Ose Pond, where once stood the offices of the Koga kubō

the country, to Echizen, Harima, and Suō, the western provinces from which the Yamana and Ōuchi forces drew their strength. The emissaries acquitted themselves well. Before long warriors of modest origin, with aspirations that had hitherto been thwarted by the rigid control of the Bakufu, stood up to contend for their own stake in the local distribution of power.

The same was true of the eastern Kantō region, for even though the state of affairs in that area had returned to a semblance of normalcy, as the tide of anarchy swept west and east in the wake of the Ōnin War, so, too, the two Uesugi strands felt obliged to once again take up arms against each other. In 1457, Yoshimasa had sent his younger brother, Masatomo, down to the Kantō to replace Shigeuji. The latter, who, following his victory over the Uesugi in the siege of Oguri castle, had reinstalled himself as the *kantō kubō* in Kamakura, was outraged and stubbornly refused to relinquish his title. Instead he moved his office to Koga, near a

small lake along the Tone River, not far from the point where the borders of the provinces of Kōzuke Shimotsuke, Musashi, and Shimōsa met. Yoshimasa's brother, meanwhile, fearful of an assault on Kamakura, had moved his office to Horigoe, in the province of Izu. From then on there were two governors for the Kantō region, the *Koga kubō* and the *Horigoe kubō*. It was, of course, an impossible situation, and neither of the two *kubō* held any sway in the Kantō. Consequently, it was the Uesugi chieftains, in their powerful post of *kantō kanrei*, who were poised to become the most powerful influence in the Kantō region. But, being a clan in the true tradition of the Warring States period, it was only a matter of years before the various strands of the Uesugi, too, began to quarrel among themselves. They fell apart into three factions and spent most of the next decade fighting each other for supremacy in the eastern provinces. By the middle of the sixties only two of the main strands were left standing: the Yamanouchi and the Ōgigayatsu.

An overgrown elevation, remains of Hirai castle

*The old gate of
Iwatsuki castle*

The Yamanouchi had their headquarters at Hirai castle, in the province of Kōzuke. The Ōgigayatsu continued to hold sway over the clan's traditional power base of Musashi province, where they had their headquarters in Iwatsuki castle. In this new climate of hostility they were joined by new upstarts who cleverly used the Uesugi rivalry to their own advantage. And thus, by the time the remains of the Western and Eastern armies had withdrawn from the capital, weary to the bone with fighting, practically all of Japan's western and eastern provinces resounded with the clamor of armor and the rattling of swords.

This state of lawlessness lasted for more than a century. The only law informing the actions of its protagonists was that of *gekokujō*, which dictated that in the absence of any constraints, those at the lower end of the hierarchical scale were free to rise against those above them and assume their positions. For a short time they would rule until it was their turn to be subdued and go under in the seething cauldron of

animosity. It was a state of total and utter lawlessness, self-defeating and futile in its deepest essence, with no definable cause and even less hope of a speedy conclusion.

It was not to a peaceful province, then, that Yamashiro returned when, somewhere toward the end of the seventies, he decided to return home. His ten years of service with the shogunal guard had left a profound impression on the man who had at one time been destined to become a local chieftain. He had experienced at close quarters the bloodiest episode in the capital's history. His first experience of fighting alongside Katsumoto's battle-hardened troops must have been a far cry from the idyllic beauty of Sawara and the soothing calm of the Sea of Katori. As always, it had been the populace who had suffered most. In the ten years that the Ōnin War lasted he had seen with his own eyes how thousands of innocent citizens had fallen prey to indiscriminate slaughter, rape, and pillage. Even more had perished in the countless fires. During the hot summer of 1467, the resulting specter had come close to that of Armageddon as the air filled with the unbearable stench of putrefying flesh and roads and rivers became clogged with those who had lost their lives in the flames. During the winter, many who had survived the flames succumbed to the biting cold, having lost both their homes and livelihoods. Perhaps the deepest impact the war had on Yamashiro was not his own immediate experience, nor that of a long-suffering populace, but the terrible contrast between the reality of war and life at

Yoshimasa's court. Being attached to the shogunal guard, he had been forced to observe how, even after the outbreak of war and against an appalling backdrop of utter mayhem and unspeakable suffering, life at court continued with an air of detachment as if nothing had happened. Thus it could happen that, in the very midst of the battle over the Shōkoku temple, Yoshimasa managed to indulge in a drinking party while his palace was shrouded in the smoke of the very building for which his men were sacrificing their lives. All he could muster was a cup of sake for his loyal retainers before they, too, were sent out to die in his name.

Yamashiro had emerged unscathed, but his ten years in the service of the guard had left profound and indelible emotional scars. Deeply disillusioned with the incompetency of the Bakufu, he left public life and returned to his home village of Sawara, but not to follow in his father's footsteps or to take up his old post as a *kebiishi* attached to the Katori shrine. Instead, Yamashiro took the vows of a

Image of Iizasa Yamashiro in old age

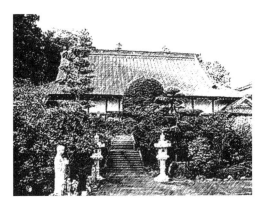

The Shinpuku temple, the place where Chōisai spent his last days as a Buddhist monk

Buddhist monk and assumed the spiritual name of Chōisai. It is not certain to which monastery Chōisai retired, but one of the temples that seem a likely place is the Shinpuku temple, which lies only a stone's throw from the shrine of Katori, the place where the swordsman had spent most of his youth and the proximity of which will have instilled in him a sense of home.

In this choice lies the second key to the profound change the war had wrought in the swordsman's heart and mind. Shintō is an outward-looking cult, celebrating life and optimistic in its outlook. Yamashiro turned instead to Buddhism, a religion that is deeply introspective and essentially pessimistic. This spirit of pessimism is most potently distilled in the concept of *mappō*. This Buddhist doctrine had emerged during the eleventh century, the century that witnessed the initial rise of the warrior class. It had been a period of increasing civil tumult that had culminated in the Hōgen Insurrection and eventually the Gempei War (1180–85).

There had been much misery and hardship throughout the period, and the accompanying fears, amplified by popular superstitions, had led many to believe that they had entered a degenerate age, that there was a decline in the adherence to Buddhist law (*mappō*), and that man was powerless to save himself by his own effort. If anything, Yamashiro's generation was even more afflicted with such miseries, and as future prospects became bleak, so the *mappō* worldview again took hold of the philosophically inclined. It seems that, through his experiences during the Ōnin War, Yamashiro, too, had come to embrace such a worldview. Even in his writings on the art of fencing, views on Buddhist law take a prominent place. In effect, the old man's harrowing experiences had turned him into something of a pacifist. The art of war, according to Chōisai, was the art of peace (both arts are pronounced *heihō* in Japanese, though written with different characters). In his view, the ultimate aim of the warrior was to settle a conflict without fighting.

Though Chōisai had entered a monastic order, he continued to both practice and teach his art of swordsmanship. His ten years in the service of the Samurai Dokoro must have brought him into contact with a large number of different styles of fencing from all parts of the country. But it seems that Chōisai stayed largely true to the ancient style of fencing practiced by the *hafuribe* of the Katori shrine, whose techniques had seen him through the tumultuous years of the Ōnin War. That much, at least, is borne out by the name

that he attached to his school of swordsmanship, which he called the Tenshin Seiden Katori Shintō-ryū, the Genuine and Authentic Katori Shintō School of Fencing.

The old master gathered a large following of aspiring young swordsmen around him. Among them the one who contributed the most to the continuation of Chōisai's school of fencing was undoubtedly Matsumoto Masanobu. It is not unlikely that Chōisai had trained with Masanobu's father and even his grandfather, for, like the Urabe, the Matsumoto were a line of *hafuribe* who served at the Kashima shrine. The lineages of these families were ancient and complex. In Masanobu's time there were four families serving as *hafuribe* at the Kashima shrine, the Matsumoto, the Ogano, the Nukaga, and the Yoshikawa. The Yoshikawa descended directly from the Urabe and were thus the true inheritors of Kuninatsu Mahito's legacy and the various fencing techniques that had been developed by the *hafuribe* of the Urabe clan. All four families belonged to the house of the Hitachi Daijō Kashima and together formed the Kashima Shitennō, from whose ranks were drawn the *hafuribe* for the Kashima shrine.

Like Chōisai, Masanobu spent his youth acquiring the various styles of fencing associated with the Kashima shrine, yet it was only under Chōisai's tutelage and the influence of the Katori Shintō school of fencing that the talents of the young Masanobu came to full fruition. Like his master, Masanobu went on to become a great swordsman. He, too, went to the capital and served under the Bakufu. Later in life he returned to Kashima and developed his own style of

The hill on which Kashima castle once stood

fencing, which he named the Kashima Shinkage-ryū. Unlike his fencing master, however, he was not to enjoy a peaceful old age. During the first decades of the sixteenth century, internal feuds came to undermine the long-standing harmony among the various lineages of the Hitachi Daijō Kashima. The dispute was finally settled in a fierce contest for Kashima castle, situated not far from the Kashima shrine and the seat of the Daijō patriarch. In 1524, during one of the many battles between the competing strands of the Hitachi Daijō fought on the nearby plains of Takagahara, the fifty-seven-year-old Masanobu lost his life.

Masanobu's style of fencing, however, survived. It was a member of the Yoshikawa line of the Hitachi Daijō Kashima house that ensured the survival of Masanobu's, and thereby, Chōisai's heritage. The name of that man was Yoshikawa Takamoto. As a direct descendant of the Urabe, and thus a *hafuribe* by birth, the young Takamoto, too, was initially primed in the tenets of the Shintō tradition of fenc-

ing, in his case the Kashima Chūko-ryū. And, like Masanobu, he too felt the powerful influence of Chōisai's school of fencing. Born in 1489, the year following Chōisai's death, Takamoto never met the old master. His first experience of the formative influence of Chōisai's school of fencing came at the age of ten. At that tender age, he was adopted by Tsukahara Tosa no Yasumoto, lord of Tsukahara castle and an influential local chieftain who had just lost his only son and heir. Yasumoto had known Chōisai and was studying Chōisai's teachings on the art of fencing under Matsumoto Masanobu at the time he took Takamoto under his wing. It was from his adoptive father that the young Takamoto acquired Chōisai's techniques and received his new name, Tsukahara Shinsaemon Tosa no Kami. It was the first step on a long road to fame, and it was his new surname that was to form the first part of the name by which he would one day become known throughout the country, Tsukahara Bokuden (the second part being an adaptation of

An elevation in the landscape is all that remains of Tsukahara castle

113

the first character of the Urabe name). Having made his appearance well after Chōisai's demise, Bokuden played only a marginal role in the establishment of Chōisai's legacy, yet his unparalleled mastery of Chōisai's techniques and the innumerable occasions on which he affirmed that mastery made him into a forceful and convincing propagator of the Shintō school of fencing.

Like Chōisai before him, Bokuden realized that it had been all the strands of the Shintō tradition of fencing that had contributed to his art, whether the Kashima Chūko-ryū practiced by his ancestors at the Kashima shrine, the Tenshin Seiden Katori Shintō-ryū practiced by Chōisai at the Katori shrine, or the Kashima Shinkage-ryū developed by Masanobu and passed on to him by his adoptive father, Yasumoto. Thus he called his style of fencing the Shintō-ryū, although written with different characters to emphasize the renewed fusion of the various styles. In him, the Shintō styles that had been practiced at the shrines of

Tsukahara Bokuden, the great propagator of the Shintō school of fencing

Katori and Kashima had been reunited, for Chōisai had been the first to bring the two traditions together. Even though his school of fencing bore the name of the Katori shrine, Chōisai had broken the fixed molds into which the various strands of the Shintō tradition of fencing had hardened. It had been he who had reached out by crossing the Sea of Katori to study the styles of Shintō swordsmanship practiced by the *hafuribe* of the Kashima shrine. And it was this remarkable cross-fertilization that gave the Shintō school of fencing its enduring strength and vigor, a vitality that helped it evolve into one of the three major schools of fencing during the following centuries. Chōisai's contribution was unique in that he not only united the Katori and Kashima strands of the Shintō style of fencing, but he also went on to forge them into a comprehensive school of fencing with its own ceremonial form and philosophical framework. Even the teachings that underpinned the Tenshin Seiden Katori Shintō-ryū were a finely tuned synthesis and bore the indelible stamp of Chōisai's life experience, a fusion of the Shinto convictions of his youth and the Buddhist insights of his latter years. As such, Chōisai was the true founding father of the Shintō-ryū, an art of fencing that is still practiced today.

Chōisai died in 1488. His remains were buried in a tomb on the premises of the shrine of Katori. There, at one of Japan's most ancient shrines, one can still observe many a practitioner of the Shintō school of fencing pass through the shrine's impressive main gate to pay homage to the founding father of their ancient yet still prospering school of fencing.

Tomb of Iizasa Chōisai Ienao, set among the plum trees of Umekiyama

There, to the left of the shrine's second *torii*, on a small slope called Umekiyama (Plum Tree Hill), where he once practiced his budding fencing skills on the surrouding trees as a young boy, rest the remains of one of Japan's greatest swordsmen.

PRINCIPAL FIGURES IN THIS CHAPTER

Ashikaga Mochiuji: *Kantō kubō* who fell out with his deputies and was eventually forced by the Bakufu to commit suicide.

Ashikaga Shigeuji: Son, successor, and revenger of *kantō kubō* Ashikaga Mochiuji.

Ashikaga Takauji: Chief general of the Northern Court and first shogun of the Muromachi Bakufu.

Ashikaga Yoshimasa: Eighth shogun of the Muromachi Bakufu, who held office during the years that Chōisai served in the shogunal guard.

Ashikaga Yoshimitsu: Grandson of Ashikaga Takauji and third shogun of the Muromachi Bakufu, who took the initiative to reunite the Northern and Southern courts.

Chiba Morotsune: Son of Chiba Tsunetane and founder of the Sōma clan.

Chiba Munetane: Father of Chiba Tanesada. His early death in Kyushu caused the leadership to be transferred to his brother Tanemune.

Chiba Sadatane: Cousin of Chiba Tanesada and main rival for the leadership of the Chiba clan.

Chiba Tanemune: Father of Chiba Sadatane. He succeeded to the Chiba leadership on the early death of his brother Munetane.

Chiba Tanenao: Fourteenth leader of the Chiba clan, who died in the siege of Tako and Shima castles.

Chiba Tanenobu: Son of Chiba Tanenao.

Chiba Tanesada: Direct descendant of Chiba Tsunetane and the man destined to become the new leader of the Chiba clan.

Chiba Yoritane:	Grandfather of Chiba Tanesada and Chiba chieftain when he was killed during the first Mongol invasion.
Enjō Terauji:	Vassal and adviser of Chiba Tanenao and lord of Tako and Shima castles.
Fujiwara Chikamasa:	Son of Fujiwara Chikamichi and attacker of the Chiba mansion.
Fujiwara Chikamichi:	Governor of Shimōsa during Chiba Tsunetane's time.
Fujiwara Haruaki:	Landowner in the province of Hitachi and fellow rebel of Taira Masakado.
Fujiwara Hidesato:	General sent down to the Kantō to crush the Masakado rebellion.
Fuijwara Kanaie:	Eighth imperial regent and father of Fujiwara Michinaga.
Fujiwara Michinaga:	Eleventh imperial regent and most influential of Fujiwara leaders.
Fujiwara Mototsune:	Second imperial regent and first Fujiwara leader to become *kanpaku*.
Fujiwara Sumitomo:	Pirate leader who conspired with Taira Masakado to seize the throne.
Fujiwara Yorimichi:	Twelfth imperial regent, who ruled during the time of Taira Tadatsune's rebellion.
Fujiwara Yoshifusa:	Leader of the Fujiwara clan and first imperial regent.
Go-daigo:	Emperor of the Southern Court.
Hara Tanefusa:	Former Chiba vassal and regent who turned against Chiba Tanenao.
Hatakeyama Masanaga:	Adopted son of Hatakeyama Mochiyuki and backed by Hosokawa Katsumoto in his unsuccessful claim for the hereditary post of *Kyōto kanrei*.

Hatakeyama Mochiyuki: *Kyōto kanrei* and leader of the Hatakeyama clan.

Hatakeyama Yoshinari: Son of Hatakeyama Mochiyuki and backed by Yamana Mochitoyo in his successful claim for the hereditary post of *Kyōto kanrei*.

Hōjō Sadamasa: General of the Kamakura Bakufu, who was routed at Tsurumi by Chiba Sadatane and Oyama Hidetomo.

Hōjō Takatoki: Regent of the Kamakura Bakufu, who was defeated by Nitta Yoshisada and committed suicide at the Tōshō monastery.

Hōjō Yasuie: General of the Kamakura Bakufu, who was routed at Bubaigawara by Nitta Yoshisada.

Hosokawa Katsumoto: Adviser to Ashikaga Yoshimasa and leader of the Eastern Army.

Makuwari Yasutane: Former vassal of Chiba Tanenao and ally of Hara Tanefusa.

Matsumoto Masanobu: Practitioner of the Kashima Shintō-ryū, who studied under Chōisai.

Minamoto Mamoru: Vice-governor of Hitachi and close ally of Taira Kunika.

Minamoto Tsunemoto: Founder of the Seiwa Genji and one of the generals sent down to the Kantō to crush the Masakado rebellion.

Minamoto Yorinobu: Vice-governor of Hitachi and the new commander sent to crush the Tadatsune rebellion.

Minamoto Yoriyoshi: Son of Minamoto Yorinobu and general sent down to Mutsu to crush local rebellion.

Minamoto Yoshiie: Son of Minamoto Yoriyoshi and second general to be sent down to Mutsu to crush local rebellion.

Nakahara Narimichi:	General sent down to the Kantō to crush the Tadatsune rebellion.
Nitta Yoshisada:	Leader of the loyalist campaign.
Ōuchi Masahiro:	Constable of Suō and ally of Yamana Mochitoyo.
Oyama Hidetomo:	Hitachi loyalist who joined forces with Chiba Sadatane to overthrow the Hōjō in Kamakura.
Sakurada Sadakuni:	General of the Kamakura Bakufu who was routed at Kotesashi by Nitta Yoshisada.
Shiba Takatsune:	General of the Muromachi Bakufu who persuaded Chiba Sadatane to defect.
Sōma Chikatane:	Bakufu general with whom Chiba Tanesada joined forces to recapture Inohana castle.
Taira Kunika:	Uncle and adoptive father of Taira Masakado.
Taira Masakado:	Grandson of founding father Taira Takamochi and first great rebel to threaten the Fujiwara hegemony.
Taira Naokata:	General sent down to the Kantō to crush the Tadatsune rebellion.
Taira Sadamori:	One of the generals sent down to the Kantō to crush the Masakado rebellion.
Taira Tadatsune:	Great-grandson of founding father Taira Takamochi and second great rebel after Taira Masakado to threaten the Fujiwara hegemony.
Taira Tadayori:	Son of Taira Yoshimochi and vice-governor of Kazusa.
Taira Takamochi:	Grandson of Emperor Kanmu and founder of the Shimōsa line of the Taira.

Taira Tsunemasa: Son and heir of Taira Tadatsune, who gained the favor of Minamoto Yorinobu.

Taira Yoshimoji: Son of Taira Takamochi and vice-governor of Kazusa.

Tomiko: Wife of Ashikaga Yoshimasa.

Tsukahara Yasumoto: Lord of Tsukahara castle and practitioner of the Katori Shintō-ryū.

Uesugi Norizane: Deputy to *kantō kubō* Ashikaga Mochiuji forced to flee to Hirai castle.

Uesugi Ujinori: Deputy to *kantō kubō* Ashikaga Mochiuji and the man who rose in revolt following his dismissal.

Yamana Mochitoyo: Rival of Hosokawa Katsumoto and leader of the Western Army.

KAMIIZUMI ISE NO KAMI NOBUTSUNA

(Kamiizumi Hidetsuna)

上
泉
伊
勢
守
信
綱

Eishō 5 – Tenshō 5
(1508–77)

There is another great swordsman in the history of Japanese fencing whose early youth was spent not far from the banks of the mighty Tone River, albeit some one hundred miles from the place where Iizasa Yamashiro was raised. He was born in 1508, into a family whose original clan name was Ōgo. The founder of the Ōgo clan was Ōgo Shigetoshi, a warrior of Ashikaga descent who hailed from the west coast of Japan. During the great upheavals of the Ōnin War, one of Shigetoshi's descendants, a man by the name of Ōgo Yoshihide, left his hometown in the province of Tōtōmi, along the Pacific Ocean. He and his family moved to the province of Kōzuke to settle in a hamlet called

Kamiizumi, just north of the village of Umayabashi (present-day Maebashi) and in the shadow of Mount Akagi. In the tradition of feudal lords, Yoshihide took on the name of Kamiizumi. The Kamiizumi clan did well in their new place of abode. By carefully negotiating the upheavals that attended the growing rivalry between the great warlords in the Kantō region, they managed to secure a small estate at the foot of Mount Akagi a few miles east of Umayabashi. There, on the southern slopes of the mountain, they built a castle and, as a reminder of the clan's origins, named it Ōgo castle. And it was at Ōgo castle that the founder of the most successful school of fencing of the next century was born. His name was Kamiizumi Hidetsuna.

Hidetsuna's father was Kamiizumi Hidetsugu. In the larger feudal scheme of things, Hidetsugu was only a minor

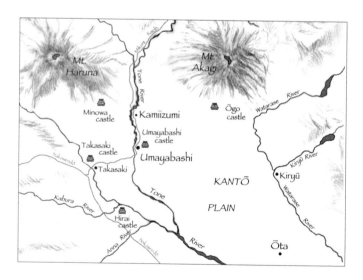

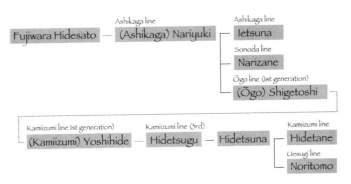

Line of descent from Fujiwara Hidesato to Kamiizumi Hidetsuna and his sons

local lord, but he was his own master and heir to a long and proud tradition. The Kamiizumi clan claimed an ancestry that ran all the way back to the famous Fujiwara Hidesato, known by lovers of Japanese martial history as Tawara no Tōta, the great warrior from Shimōtsuke who had once helped bring the rebellious Taira Masakado to heel.

Legend has it that, on one of his visits to Kyoto, Tōta was about to cross the bridge over the Seta River, at the southern tip of Lake Biwa, when he saw lying on the bridge a snake of enormous proportions. Undaunted, he simply walked up to the snake and stepped over it to continue his journey. It so happened that the snake was none other than Ryūjin, the Dragon King and lord of the sea, lakes, and rivers, who had taken on the shape of a snake to rest his weary body in the warm summer sun. Deeply impressed with Tōta's pluck, the Dragon King invited the warlord to his palace at the bottom of the sea. Not the kind of man to decline such an offer, Tōta accepted the invitation. During

125

*Tawara no Tōta
at the court of
the Dragon King*

Tōta's visit to the underwater palace, the Dragon King presented the warrior with the gift of a sword cast in gold and an exquisitely decorated scabbard. This sword, according to the Dragon King, would slay all against whom it was used and make its owner shogun. Tōta never made it to shogun, but he did manage to rout the formidable Taira Masakado by way of a ruse. In fact, it was from this historical feat that his legend grew until it eventually evolved into the famous fable of Urashima Tarō, the simple fisherman who leaves his home village to seek his fortune (and find the love of his life) at the deep-sea Palace of the Dragon King. Such were the tales on which the young Hidetsuna was raised and that shaped his worldly outlook.

By the time Hidetsuna had reached his twenties, he, too, yearned to venture into the world to seek his fortune and prove his worth. Like the young Yamashiro, Hidetsuna was raised in the martial tradition, and like the latter, his weapon of choice was the *taitō*, or long sword. His father, too, was a

126

swordsman of note, who, when young, had studied the art of fencing under Iizasa Chōisai and a number of other famous swordsmen. One of them was a certain Aisu Ikō.

Ikō was a swordsman of great repute, who, through his remarkable exploits, had already become a legend in his own life. The Aisu clan hailed from the province of Ise. They were a clan of *wakō*, pirates, who enjoyed the protection of Japan's western warlords and made their living by preying on the ships that carried silk and silver between Japan and China. Ikō, too, had led such a life and had visited China on his many voyages. His experiences deeply influenced his style of fencing, a style he gave the name Kage no Ryū, the Shadow school of fencing. At the age of thirty-six, however, he suddenly turned over a new leaf. He began an itinerant life, spending many years on the road in *musha shugyō* honing his character and teaching his followers in the Shadow school of fencing, and how to disarm one's opponent without the use of one's sword, a technique he branded *mutōtori*. As an old man, he had entered the service of Satake Yoshiatsu, the warlord of Hitachi, who had his headquarters in Ōta castle not far from the Pacific coast. There, together with his son, Koshichirō, he instructed Satake's men in the tenets of the Shadow school of fencing. It so happened that the Kamiizumi and the Satake were on friendly terms, and thus, with a letter of introduction from his father, the aspiring young swordsman set out for the province of Hitachi to seek out the old swordsman so as to master the Kage no Ryū.

Hidetsuna arrived at Ōta castle in the mid-1530s. The lord of the castle welcomed the additional strong hand, for, as so many others, the Satake clan too had fallen victim to internal rivalry. The rivalry had begun in 1534, when Yoshiatsu's younger brother, Yoshimoto, had first openly claimed his right to the leadership of the Satake clan. By the time Hidetsuna arrived at the castle, Yoshimoto had been forced onto the defensive, and much of the action had shifted to the vicinity of Hedare castle. This castle was situated some ten miles west of Ōta along the lower reaches of the Kuji River. The stronghold had formerly belonged to one of the Satake vassals, but in 1529 Yoshimoto had taken it. Over the next few years Hidetsuna was to see action repeatedly, fighting alongside the forces of Yoshiatsu in the field and being instructed in the techniques of the Kage no Ryū under the

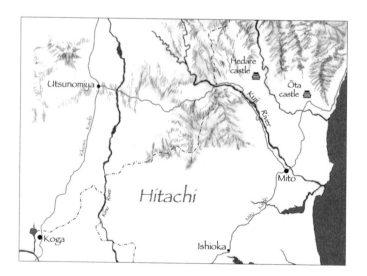

Kamiizumi Hidetsuna in his youth

aged Ikō while quartered in the castle town of Ōta. The first major engagement in which Hidetsuna took part was the battle of Ose, which was fought on the banks of the Kuji River in the summer of 1538. Another engagement, this time not far from Hedare castle, followed in 1539. The contest between the two Satake brothers came to a head in 1540 when Yoshiatsu laid siege to Hedare castle. For several weeks Yoshimoto held out against his brother, until, at the end of March, the castle fell and Yoshimoto committed suicide.

With the fall of Hedare castle the time had come for Hidetsuna to return home. He was now thirty-two years old. Two years earlier his seventy-year-old teacher had once more decided to uproot himself and travel all the way down to the province of Hyūga on the island of Kyushu. It was to be Ikō's last and longest pilgrimage, to the place that had so drastically altered the course of his life. For it had been there, on the eastern coast of Kyushu, that, on one of his voyages around the Japanese coast, he had met disaster when

the ship on which he sailed was caught in a storm. All who had been on her were drowned. All except one, that is, for Ikō had survived. He was washed ashore at a place called Udo. There, at the great shrine of Udo, the thirty-six-year-old *wakō* had undergone a spiritual renewal, an experience that had caused him to abandon his life of piracy and to take up a life of *musha shugyō*, hoping to attain spiritual enlightenment and to propagate his unique Shadow school of fencing. As he realized he was approaching the end of his long journey through life, the old swordsman wanted to return to the place that had been so instrumental in the course he had taken.

A lot had changed in the Kantō region during the time Hidetsuna had been away. Nominally, the region still fell under the jurisdiction of the Bakufu, but the real hold on power lay elsewhere, with men like Uesugi Akizane, leader of the Yamanouchi branch of the Uesugi and heir to the position of *kantō kanrei*. Apart from having to deal with the Ōgigayatsu branch of his clan, Akizane also had to contend with other claimants, many of them upstart warlords. The most ambitious and dangerous of them was undoubtedly Ise Shinkurō. This ruthless warrior hailed from the province of Izu. At the end of the fifteenth century, he had secured his hold on the Izu Peninsula, capturing by ruse the castle of Odawara, a strategic stronghold along the Tōkaidō just across the border with Sagami. But Shinkurō's ambitions were much greater. He was bent on nothing less than

*Odawara castle,
the capture of
which put Hōjō
Sōun on his road
to success*

overthrowing the Muromachi Bakufu. To give his enter-
prise an air of legitimacy, he cleverly took on the name of
Hōjō Sōun, after the illustrious Hōjō clan. They, too, had
hailed from Izu, and their eclipse of the Minamoto was a
shining example of what he had in store for the Ashikaga
shoguns. Sōun gradually widened his sphere of influence
northward. By the time of his death in 1519, he had con-
quered most of Sagami. And though he died without seeing
his chief objective materialize, his work was carried on by
his son, Ujitsuna. Five years after his father's death,
Ujitsuna crossed the border between Sagami and Musashi
and laid siege to Edo castle, a stronghold of the much
reduced Ōgigayatsu branch of the Uesugi. Had the Uesugi
made a united stand at this point they would have routed
the Hōjō forces. Yet they failed to do so. Edo castle fell,
and by the time Ujitsuna too had passed away, the Hōjō
ruled supreme in the provinces of Izu and Sagami and had
conquered large tracts of Musashi.

The most northern outpost of the Hōjō dominion was now the stronghold of Kawagoe, a post town along the Sumida River that commanded the main high roads into the neighboring provinces and which lay only some twenty miles southwest of Koga. It was a painful reminder to the Uesugi of the extent to which their sphere of influence had withered, especially that of the Ōgigayatsu branch, for, together with the castles of Edo and Iwatsuki, Kawagoe castle had been one of their three famous strongholds. All three castles had been built during the middle of the fifteenth century. Their architect had been the renowned tactician Ōta Dōkan. Commissioned by the Bakufu, Dōkan had positioned the castles along the southern banks of the main Kantō rivers to form a line of defense against the threat of the belligerent *kantō kubō* Ashikaga Shigeuji.

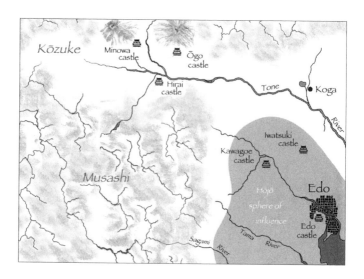

*Ōta Dōkan, architect of Edo,
Iwatsuki, and Kawagoe castles*

With Ujitsuna's capture of Kawagoe, it seemed that a final
threshold had been reached in the fortunes of the Uesugi, the
crossing of which would herald the end of their reign in
the Kantō. That much had dawned on the leaders of both the
Yamanouchi and the Ōgigayatsu branches, and throughout
the 1530s both camps devoted all of their resources toward its
recapture. Yet, still hoping to achieve sole domination in the
Kantō, they did so dividedly—a weakness on which Hōjō
Ujitsuna capitalized with great insight and cunning.

Ujitsuna's death in 1541 brought no reprieve to the increas-
ingly beleaguered Uesugi clan. His son, Ujiyasu, was, if any-
thing, even more bent on realizing his grandfather's aim. By
then, at least, the gravity of the situation had finally begun to
sink in among the two Uesugi factions. In 1545 the leaders of
the two factions, Uesugi Norimasa for the Yamanouchi and
Uesugi Tomosada for the Ōgigayatsu, united their strengths
and laid siege to Kawagoe with some eighty thousand troops.
It seemed that this time they must succeed where they had

failed for so long, for the castle was defended by not more than three thousand men.

The siege of Kawagoe castle is one of those episodes in the history of the Japanese civil war period that stands out for sheer illustrative power. In all its colorful facets it is a most powerful metaphor, of the arrogance of those in power, of the creativity and resourcefulness of those aspiring to power, and of the immutable law of *gekokujō*. And while this law had thus far served the Hōjō well, it now seemed that the grandson of the man who had set out on the conquest of the Kantō had finally exhausted its limits. As a result of the rapid expansion of the Hōjō hegemony, its troops were dispersed over a wide area. In a country rife with conflict, there were many more rivals to deal with than just the Uesugi, and while they were much smaller and posed a lesser threat, they sufficed to keep troops tied down elsewhere. Consequently, Ujiyasu was unable to raise sufficient men to attempt the relief of Kawagoe castle. He did, however, manage to safely slip a

Hōjō Ujiyasu, the great strategist in the defense of Kawagoe castle

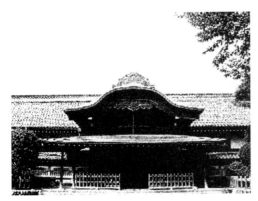

*Main hall of
Kawagoe castle*

messenger (a volunteer by the name of Kushima Katsuhiro)
through the Uesugi formations to instruct those within the
castle to refrain from any attempts to fight their way out but
to hold out until the next year, when he hoped to raise
sufficient troops to come to their aid. For six months the
men in the castle held out, surviving on increasingly sparse
provisions and praying to Buddha for their delivery.

Outside the castle walls, meanwhile, quite a different spec-
tacle evolved. As the days grew into weeks and the weeks into
months, the troops became increasingly bored with the con-
stant waiting and began to seek diversions from the daily
monotony. This was readily provided by merchants of gar-
ments, liquor, and foodstuffs, who seemed to appear from
nowhere to set up their little stalls in the camps and ply their
wares for all they were worth. As time drew on, the setlers
were followed by more seedy characters of the military camp,
the gamblers, the artists, and the prostitutes. These develop-
ments were curbed by neither of the two Uesugi warlords.

135

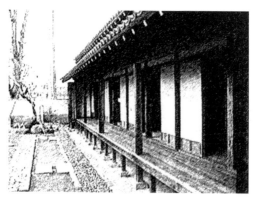

Quarters of Kawagoe castle's chief retainers

Indeed, being a man given to worldly pleasures, Norimasa seemed to lead by example, for the feasts at his stronghold of Hirai had already become legendary. With all the ingredients in place, the diversions grew increasingly extravagant as the more senior officers began to indulge in great banquets that lasted till early in the morning. When dawn finally broke they would fall into their tents to sleep off their hangovers, secure in the knowledge that the only thing that stood between them and the castle was the lapsing of time. Such was the folly of shortsightedness, for the liquor and women that were to be had for a song were provided by none other than Hōjō Ujiyasu. Unable to resort to sheer force, Ujiyasu had resorted to ruse to achieve his aim. His plan worked remarkably well. When, by the spring of the next year, he was able to raise the number of troops he required, discipline among the Uesugi troops had fallen to dismal depths.

Ujiyasu's troops were nevertheless vastly outnumbered, for he had managed to raise only a tenth of Uesugi's forces,

some eight thousand men in all. And so he embarked on yet another ruse. Instead of engaging the enemy head-on, he divided his forces into small groups, which made short, targeted sorties into the areas occupied by the Uesugi, only to withdraw as soon as the enemy responded. They were small pinpricks, painful enough to rouse the vast Moloch from its slumber yet short enough to spare his men. Having pursued this strategy for several weeks, he next sent spies into their camps to test the mood among the enemy troops. As Ujiyasu had expected, the constant withdrawal of his troops had lulled the enemy into a false sense of security; they thought his troops were battle shy and not a serious force to reckon with. The time had come for Ujiyasu's men to show what they were really worth.

On the evening of May 29, 1546, capitalizing on the nocturnal nature of his opponent's indulgences, Ujiyasu divided his troops into four groups of two thousand each and gave them a brief as short as it was ingenious. All men were

Kawagoe castle interior

ordered to attach sheets of white paper to their harnesses and leave off their helmets. The cast-iron helmets were heavy and they needed to move fast. The paper was there so that they could identify each other in the dark. All those who were not marked in this way were to be cut down indiscriminately. They were to take no hostages and no heads of officers— something that medieval custom required. At no time were they to linger or flock together. Only on the signal of a horn were they to assemble, regroup, and resume the attack.

The battle at Kawagoe was undoubtedly Ujiyasu's finest hour, for the Uesugi forces were utterly routed. For some two hours they were thrown into complete confusion. Stirred into action by the clamor outside the castle walls, those within Kawagoe castle, though greatly weakened by the six months they had subsisted on minimum rations, used their last strength to throw open the castle gates to welcome Ujiyasu's forces. When these had finally withdrawn from the field of battle, more than ten thousand of their enemy were slain,

Later reconstruction of one of Kawagoe castle's wooden turrets, or yagura

*The extensive
defenses of
Kawagoe castle*

among them some thirty high-ranking officers. Ujiyasu's forces, meanwhile, had suffered only a few hundred casualties. Thus, the impossible had happened: the castle had been relieved, while an invincible force had been decimated by a force fewer in number than those who had been slain. It was a blow that left the Uesugi reeling and from which it never recovered. Uesugi Tomosada, the leader of the Ōgigayatsu, had fallen in his harness. His death spelled the end of the Ōgigayatsu branch, a clan that had once ruled supreme in the province of Musashi. Uesugi Norimasa had escaped, but only by the skin of his teeth. He had been forced to fall back to Hirai castle, some ten miles south of Umayabashi. His troops had sustained a crushing blow, but even more devastating than the loss of men was the loss of his former allies, who, both impressed and warned by the almost supernatural qualities of Ujiyasu's powers, had gone over to the Hōjō camp.

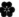

The ascendancy of the Hōjō was of great consequence to all the warlords in the Kantō region, and they were particularly troubling to the Kamiizumi clan. Hidetsugu owed allegiance to Nagano Narimasa, the lord of Minowa castle, which stood on the other side of the Tone valley at the foot of Mount Haruna. And Narimasa, in turn, was a vassal of Uesugi Norimasa. From the turn of the century onward, Hidetsuna's father had watched with growing concern how the Hōjō were gradually encroaching on Uesugi territory. Thus far Ōgo castle had been spared any direct hostilities, but this was bound to change very soon, for the Uesugi were now harder pressed than ever. Norimasa had lost all control over the province of Musashi, and the only foothold that remained to him in the Kantō region was Hirai castle, in the eastern tip of Kōzuke province. If he were to lose Hirai too, he was bound to fall back along the Mikuni Road, the road north from Umayabashi. That road led to the Mikuni Tōge, the Three-Province Pass, which formed the gateway to Echigo, the only province where he could expect to find refuge. Sooner or later, therefore, Minowa and Ōgo castles were bound to see action. The two castles, after all, commanded the Mikuni Road and without their involvement Norimasa would be without a rear guard to cover his retreat. These were developments that the thirty-seven-year-old Hidetsuna had to face alone, for not long after his return to Ōgo castle, his father had passed away.

For another five years Norimasa held out in Hirai castle, without any serious change in the status quo. Then, in the autumn of 1551, Hōjō Ujiyasu raised a vast army to lay siege to

the last Uesugi stronghold in the Kantō. That same year Hirai castle fell. Norimasa escaped with his life and, as Hidetsuna had expected, seeing no other way out of his predicament, headed straight for Echigo. There he placed himself under the protection of Nagao Terutora, a powerful local warlord. For Norimasa it was a second reminder of the depths to which he had fallen. Terutora was the son of Nagao Tamekage, another upstart warlord, who had made his fortune a few decades earlier by supporting the Yamanouchi in their struggle with the Ōgigayatsu. In reward for his contribution, the Yamanouchi had made him the deputy to Uesugi Akisada, at that time their constable in Echigo, but within a few years Terutora had expressed his gratitude by raising a large army and removing Akisada from power. Now it seemed that all that infidelity must be rewarded, for Terutora agreed to take Norimasa under his protection only in exchange for the post of *kantō kanrei*. With no cards left to play, Norimasa submitted to Terutora's will.

It was the end of an era, for, with the death of Tomosada and the flight of Norimasa, the Uesugi hegemony in the Kantō had come to an end. With the death of Norimasa in 1579, at the hand of one of Terutora's descendants, came the ignominious end of an illustrious clan that had dominated Japan's feudal landscape for more than two centuries. Yet, like the Hōjō, the name of Uesugi lived on, for long before Norimasa's death, Terutora had himself adopted as his heir, taking on the name of Uesugi Kenshin.

The former Uesugi vassals in the Kantō, meanwhile, were left to fend for themselves. So sudden had been the collapse

Uesugi Kenshin, upstart warlord
who made himself kantō kanrei

of the Uesugi hegemony, and so sudden the rise of the Hōjō, that only the more powerful warlords were able to stand their ground. Others, like Nagano Narimasa, were able to rely on the security of their defenses.

Minowa castle was a case in point. Built at the turn of the fifteenth century by Narimasa's grandfather, Nagano Narihisa, Minowa castle was one of the most formidable strongholds in the Kantō region. It had three castle towers, and its manifold ramparts and defensive structures covered a total area of close to a hundred acres. It had withstood repeated attacks by a number of hostile warlords and was considered an untakable fortress by those who had had the dubious privilege of testing its strength. Its foundations rested on the granitelike volcanic rock of Mount Haruna and, barring an all-out siege, its elevated situation, with hidden mountain paths leading both northward and westward, enabled the uninterrupted supply of victuals and reinforcements, even during sustained attacks. It also had the benefit

143

Overgrown battlements are all that remain of Minowa castle

of being surrounded by a large number of smaller strongholds that belonged to vassals of the Nagano. During any serious attempt on the Nagano headquarters, it was these more exposed and defenseless fortifications that would be sacrificed to break the momentum of an invading force and thereby postpone an immediate siege to the last.

Ōgo castle happened to be one of these "dispensable" castles, and it did not take long before Hidetsuna, like so many other vassals throughout the Kantō, was forced to draw his conclusions. His moment of truth came in the winter of 1555, when one of Ujiyasu's vassals, Inomata Norinao, marched against Ōgo castle at the head of an army of several thousand men. For Hidetsuna it was a hopeless proposition. As a Nagano vassal, the Kamiizumi normally could have relied on at least some reinforcements, but the vacuum that had been created by the demise of the Uesugi had left even the Nagano hanging on by the skin of their teeth. Seeing himself totally outnumbered and knowing that he would not be able

to count on any support from across the valley, Hidetsuna submitted to Ujiyasu and opened the gates of Ōgo castle.

Though a humiliating blow, Hidetsuna's submission was an act that had saved the lives of many. And while Hidetsuna served his new master reluctantly, the following years were spent in relative security as there were no major conflicts to disturb the region. It was undoubtedly with the safety and future of his family in mind that Hidetsuna acted in the way he did. Following his return to the family home, a decade before, he had married at the age of thirty-five. That marriage had produced two sons, Hidetane and Norimoto. Of the two, Hidetane was the elder. Ironically, Hidetsuna's new alliance was to affect the very lives of those he sought to protect. Having reached adulthood, the young Hidetane, like his father, chose to seek his fortune. Consequently, in the early 1560s, the young warrior left the relative safety of Ōgo castle and entered the service of Hōjō Tsunashige.

Hidetane's new lord was a descendant of the Imagawa clan who had been adopted into the Hōjō clan after his father had died in battle. He had proved a valuable asset for the Hōjō, who displayed his military prowess in battle upon battle. At the time the Hōjō were at loggerheads with the Satomi clan, from Satomi village in Kōzuke. They were a formidable enemy, direct descendants of none other than Nitta Yoshisada. The rivalry between the two clans was a particularly fierce one that went back several decades. The first major showdown had taken place in 1538. In that battle, fought on the banks of the Edo River near the village of Kōnodai (present-day Kokufudai), the Hōjō had obtained a

The tranquil Edo River, on whose banks the young Hidetane lost his life

resounding victory. Yet they had left a sting in their opponent, and by the time Hidetane had entered the service of Tsunashige, the Satomi had recovered from their losses and were again preparing for war. The second showdown between the two clans came in the first month, 1564. Again it was fought at Kōnodai, against the deceptively tranquil backdrop of the Edo River, and again the Hōjō were victorious. This time, however, the victory had come at a cost, for Tsunashige's men had sustained a great number of casualties. For Kamiizumi Hidetsuna, too, the price he paid for his allegiance to the Hōjō was a heavy one, for on some frosty plain somewhere along the lower reaches of the Edo River, his firstborn had fallen in battle.

Fate, however, had more vicissitudes in store for Hidetsuna. This time it was the rivalry between two other warlords that was to upset the fortunes of the Kamiizumi clan. One of

them was Uesugi Kenshin. In spite of his dubious origins, the young Kenshin proved a worthy successor. Like his rival Hōjō Ujiyasu, the young warlord was totally bent on realizing his father's dreams of winning back the Kantō. Early in 1560 he raised a vast army that he led across the Mikuni Pass in a bid to win back what Norimasa had lost. It was an ambitious goal, for in order to achieve it he would have to start virtually from scratch. Almost a decade had passed since his adoptive father had crossed the same pass in the opposite direction on his flight from the Hōjō onslaught. By this time, virtually all of the former Uesugi vassals in the Kantō had gone over to the Hōjō, either out of free will or, like Hidetsuna, to secure the continued governance of their own estates. In retrospect, Hidetsuna's had been a wise move, for now, with the news of Kenshin's approach, he was able to reconsider his options. When, therefore, Hidetsuna heard of Kenshin's designs, he sent secret word to Echigo, reminding Kenshin of the strategic value of his stronghold and requesting assistance so that he could evict the Hōjō forces from Ōgo castle. His request was answered. No sooner had Kenshin recaptured the castle of Umayabashi than he sent a large force across the Tone River to relieve Ōgo castle.

Apart from recapturing Hirai and a number of other castles in the neighborhood, Kenshin's plans to regain what his adoptive father had lost came to nothing. Since Norimasa's flight, the power relations in the Kantō region had shifted beyond recognition. Where the power brokers of the preceding decades had been the two branches of the Uesugi clan, now it was new warlords, all from a different pedigree,

Takashima castle, situated on the shores of Lake Suwa

who dominated the feudal landscape. For the time being Ujiyasu was the one who ruled supreme. But, apart from Kenshin, there were other, equally ambitious and equally ruthless men who had their designs on the Kantō.

One such man was Takeda Shingen, the new warlord of Kai province. In 1551, the same year that Uesugi Norimasa had fled to Echigo, the twenty-year-old Shingen had risen to power, and a measure of his scruples, or rather their lack, was the way in which he did so. In the summer of that year his father, Nobutora, following a long and successful military campaign to subdue his rivals in Kai, had returned home to find that his son had staged a coup by blocking all the roads leading toward the family estate of Yōgaisan castle and proclaiming himself the new leader of the Takeda clan. Nobutora was never again to see the castle he had built with his own hands. For the next thirty-three years he was forced to live the life of a refugee, dying in exile at the age of eighty-one.

Despite his shortcomings as a son, in military terms, Shingen proved a worthy successor, for in his military exploits the son soon outshone his father. Aware of the strength of the Hōjō, he was quick to reach a truce with Ujiyasu. This enabled him to add to his father's achievements by expanding his territory northward, into the province of Shinano. In this he was highly successful. By the middle of the century he had conquered large parts of the province, including impressive strongholds such as Takashima castle on the banks of Lake Suwa and Matsumoto castle in the town of the same name, some twenty miles farther north. In doing so, Shingen came dangerously close to the borders of Echizen, the home country of Uesugi Kenshin, whose power base, Kasugayama castle, overlooked the Bay of Naoetsu on Japan's west coast.

But it was more than Shingen's encroachment on Kenshin's territory alone that brought these two powerful warlords of the Warring States period together in combat.

Matsumoto castle, the second to be captured by Takeda Shingen in his drive northward

149

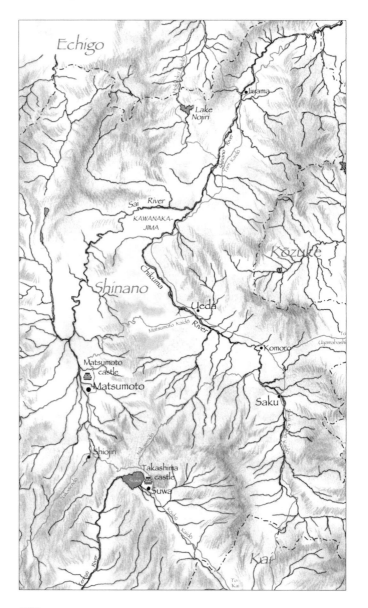

Theirs was a curious meeting of minds, for while they only ever met in battle, they invariably relished the prospect of testing each other's mettle. They did so repeatedly from 1553 onward, when their forces met at Kawanakajima, a wide, triangular plain at the confluence of the Chikuma and Sai rivers just south of Nagano.

It is believed that the two rivals met at Kawanakajima as many as five times. The fiercest encounter was fought on September 10, 1561, when a total of some forty thousand men locked in combat on the plains of Kawanakajima. At the end of a day of intense fighting, when both parties began to count the heads they had taken, Kenshin's forces counted more than four thousand, while those of Shingen counted more than three thousand. Both leaders claimed victory, but in truth this battle, though famous, and in spite of having been fought on such a grand scale, made neither of them any wiser. Nor were any of the other four encounters at Kawanakajima to have any lasting effect on the distribution of power in the region or the country as a whole, for that matter, fought as they were on the periphery of the medieval centers of power.

The last encounter at Kawanakajima came in 1564. Both forces duly set up their camps and took their positions. But that was all they did. For weeks they stared at each from across the so familiar battlefield without ever once seriously engaging in combat. As the warriors sat around their campfires and the evening mists came drifting in from over the waters that had once turned red with the color of their comrades' blood, so the memories of three years before came rushing back to haunt their minds: the deafening

clamor of the battlefield, the sight of horses in their death throes, the smell of blood, and the feeling of spilled gore underfoot—all came crowding in upon their senses in one overpowering surge as if it had only been yesterday. At length, after a standoff that lasted close to two months and that saw only some desultory volleys, both forces began to break camp and to withdraw from the battlefield. It seemed that after so many battles and so much bloodshed, without any definitive purpose, the troops had finally lost the stomach for more of the same.

The rivalry between the two warlords, however, continued unabated. And where Shingen had failed to rout Kenshin in Shinano, he sought to get the better of him in the Kantō. Although Kenshin had failed to carry through his ambitious plans for the Kantō, through his renewed alliance with the likes of Nagano Narimasa and Kamiizumi Hidetsuna, he had established a considerable foothold in the Kantō, and to many at the time it must have seemed that he was on the verge of a breakthrough. Great strategist that he was, Shingen realized that the strategic positions of Minowa and Ōgo castles could also be turned against Kenshin. In Kenshin's hands the castles were an ideal base from which to launch a new campaign to regain the Kantō. In Shingen's hands, the castles could be used as a barrier to halt Kenshin's progress and perhaps even as a base for a similar campaign against Echigo. Thus far, however, Minowa castle in particular had proven a hard nut to crack. This was not only due

to the castle's redoubtable defenses and strategic situation.
It was also in capable hands. Both Nagano Nobunari and his
son Narimasa had proven themselves able warriors. Indeed,
Narimasa had repeatedly repelled similar attempts by
Shingen in the past. In the autumn of 1561, however, the
pendulum of fortune seemed to have swung in Shingen's
favor. In that year, while staying at the post town of Saku,
and still nursing his wounds incurred at Kawanakajima, word
reached Shingen that the lord of Minowa castle had died. He
had been succeeded by his son, the seventeen-year-old
Narimori, a valiant but inexperienced youth. Shingen had
intended to act on this information, but more pressing
engagements had diverted his immediate attention. Two
years later another card was played into his hands when he
received secret word from Wada Norishige, the lord of
Takasaki castle, that he was willing to negotiate a truce. For
Shingen it was a splendid piece of news and one to which he
replied with alacrity. The Wada had been a long-standing

Takasaki castle,
whose lord,
Wada Norishige,
became Takeda
Shingen's ally

153

ally of the Uesugi, and though Takasaki castle was nothing like Minowa castle in its dimensions, it was of considerable strategic value, being situated at the heart of Nagano territory. At the time he had still been fighting Kenshin in Echigo, but now, with the last campaign at Kawanakajima behind him and with his full force at his disposal in Kai province, he decided to put his old plan into action.

Early in September 1566, Shingen departed from Saku at the head of some ten thousand men, crossed the Yoro Pass, and set out toward the village of Takasaki. He left a trail of destruction on the way, razing the castles of Nishiboku, Takada, and Kuragano, Narimori's first line of defense. By the end of September, he had reached Takasaki. From there he marched northward, reaching the village of Misato by January 1567, when he laid siege to Minowa castle.

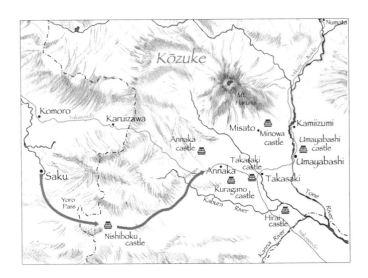

*Today, only the
outbuildings
remain of
Annaka castle*

In spite of his youth, Narimori had prepared himself well
for the pending attack. News of Shingen's approach had
reached Minowa castle well before the end of the previous
year. This had given him some two months to strengthen the
castle's defenses, stock up on provisions, and rally his vassals
around him. These included men like Fujii Bungo, Akana
Buzen, Terao Bingo, and Nagano Shuzen. They were only
four among a group of men called the Nagano Jūroku no
Yari, the Sixteen Lances of Nagano. All of them were battle-
hardened men who had built a reputation for valor and mar-
tial prowess in the course of numerous battles in the service
of Narimori's father, Nagano Narimasa. Among them also
was Kamiizumi Hidetsuna. He had been the first to come to
blows with Shingen's men when he had been prevailed upon
by Annaka Tadamasa to help in the defense of Annaka cas-
tle. Like all the other strongholds, Annaka castle had fallen
and Tadamasa had been forced to commit suicide. Yet the
victory had not been effected without a great number of

casualties on Shingen's side. Now Hidetsuna was called upon to help Narimori in the defense of Minowa castle. With only a force of a few thousand men, the odds were heavily against the castle's defenders, but at least they knew that they had done everything in their power to withstand a siege.

It did not take Shingen long to draw that very conclusion. After two major frontal assaults over the first few weeks of the siege, the castle still stood. Moreover, apart from repulsing the attacks, those inside made little attempt to make a breakout—a clear indication that they had prepared themselves for a long siege. Not a man given to patient waiting, Shingen now decided to take a different approach. There were various strategies that contributed to the success of siege warfare, two popular variants being the digging of tunnels and arson. In the case of Minowa castle, these techniques were of no use, as the structure of the castle itself was largely of stone, while its foundations rested on the hard and impenetrable volcanic rock of Mount Haruna. There was, however, one weak point in the castle's defense. Most of Japan's medieval castles drew their water from wells. Given the importance of a constant supply of drinking water, the wells were usually situated in the basement of the castle's innermost keep, the *honmaru*, where they enjoyed nearly the same degree of protection as the womenfolk, who were locked up in the *honmaru*'s upper stories during a siege. Having been built on rock, Minowa did not possess a well from which to draw water. Consequently, the castle's impenetrable defense was at the same time its Achilles' heel, for in order to quench their thirst, its occupants had to draw

Steps to the watering place of Minowa castle

water from outside the castle, from a small mountain stream. It was a weakness that was quickly spotted by the seasoned strategist. He thus ordered the stream to be diverted, away from the castle, so as to deprive its occupants of their most vital lifeline.

It was only a matter of days before Shingen's measure began to take its toll on those within. Had it been late spring, the torrential downpours of Japan's rainy season would have been sufficient to keep the castle's occupants from dying of thirst. Now Narimori faced two equally difficult options: surrender, and almost certainly be doomed to the same fate as Annaka Tadamasa, or make a last, valiant stand. The young and inexperienced warrior chose the latter option. And thus it was that, on February 22, 1567, the gates of Minowa castle were flung open and the twenty-four-year-old Narimori, together with a force of some two hundred men, stormed out in a last desperate attempt to break through the ranks of Shingen's overwhelming forces. It was an impressive

but ultimately futile display of bravery. The war tale *Minowa gunki* relates how the young lord of Minowa rushed headlong into the enemy's defenses and how, having struck down close to a dozen of Shingen's men, the young lord of the castle was eventually cut down himself. Only a small number of men were finally able to break through the enemy's line, among them Kamiizumi Hidetsuna.

For Hidetsuna there was no castle to fall back on. He had left no one behind to man Ōgo castle and had put all of his men at the disposal of Narimori. During the siege of Minowa castle, part of Shingen's army had been dispatched to torch all the strongholds in the vicinity. Ōgo castle was one of them. It was the nadir in the fortunes of the Kamiizumi clan, a fortune shared by so many other feudal lords during the Warring States period. Severely wounded, the fugitive warrior spent several anxious days on the run from Shingen's men. He did so

A dusty tree-lined path, sole remains of Ōgo castle

Hikida Bungorō, one of the two young swordsmen who escaped with Kamiizumi Hidetsuna

in the company of Jingo Muneharu and Hikida Bungorō. Muneharu was the son of a samurai from the village of Hachiōji, some twenty miles west of Edo. Bungorō hailed from the other side of Japan, from Ishikawa, in the province of Kaga on Japan's west coast. He was Hidetsuna's oldest and favorite pupil, related to him through his mother, who was Hidetsuna's sister-in-law. Both Muneharu and Bungorō had served Hidetsuna when he was still lord of Kamiizumi castle and both had fought under his command during the defense of Minowa castle. They had been among the few who had managed to break through the Takeda ranks, and it was largely with the help of these two loyal retainers that the severely wounded warrior managed to reach the village of Kiryū, some twenty miles east of Umayabashi. There the exhausted men found refuge at Kiryū castle. This castle belonged to Kiryū Suketsuna. Four years younger than Hidetsuna, Suketsuna, too, had pledged his allegiance to Uesugi Kenshin when the latter had marched on the Kantō seven years before.

159

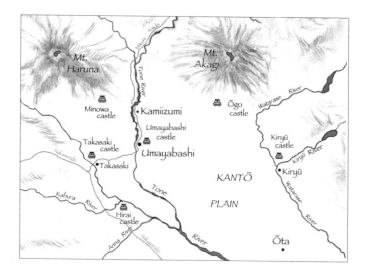

Strategically situated at the confluence of the Watarase and Kiryū rivers, Kiryū castle was to become one of the few castles that held out against the onslaught of Shingen's forces.

For several months the battle-weary and now homeless swordsmen remained at Kiryū castle, nursing their wounds and enjoying the hospitality of Suketsuna. During this period word arrived at Kiryū castle that Shingen had appointed one of his vassals, Naitō Masatoyo, as the new master of Minowa castle. Moreover, it appeared that through Masatoyo, Shingen had heard of the Sixteen Lances of Nagano. He had been deeply impressed with the accounts of their valor and had sent out word that he was willing to recruit them among his own men. If willing to take up his offer, they were to report for duty at his new headquarters of Takashima castle. This, too, was customary in feudal Japan; indeed, in a society

in which little value was placed on human life, it was quite a privilege. And thus, the three men retraced their steps, this time not as refugees, furtively making their way along hidden by-roads, but as proud warriors on horseback, to Lake Suwa to keep their appointment with their former foe.

It must have been with mixed emotions that, in the last weeks of March 1567, the three warriors crossed the imposing bridge across the moat of Takashima castle. Only two months earlier their prospects for survival had seemed exceedingly bleak and all had expected to die. Now the future held new prospects, and it was clear to all three of them that those prospects would be shaped in no small measure by the hours that were to follow. None of them, however, could have anticipated the reception they were about to receive, for when they dismounted and entered the imposing interior of the castle's main hall, they found to their astonishment that they were awaited by none other than the warlord of Kai himself. As a man of arms Shingen

The old bridge across the moat of Takashima castle

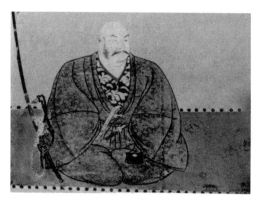

Takeda Shingen of Kai, who gave Kamiizumi Hidetsuna his new name

valued and respected a good warrior, and he had wanted to meet Hidetsuna in person in order to ask him to enter his service as his personal fencing instructor. It was a remarkable gesture of magnanimity. This almost paradoxical quality in an otherwise so utterly ruthless warlord (who had risen to power by expelling his own father) had earned him the respect of all his enemies. Even his archenemy Uesugi Kenshin recognized and deeply respected his martial integrity. So much so, that when, early in 1568, the Hōjō sought to put pressure on Shingen by banning all exports of rice and salt to the landlocked provinces of Kai and Shinano, he immediately issued orders for a large quantity of salt to be sent to Takashima castle with the words "our conflict is one of bows and arrows, not of rice and salt."

For a second time in little more than a decade Hidetsuna had come close to the brink of destruction at the hands of a superior force, and for a second time he had (by that same hand) been offered a means of survival. The first time it had

been offered by Inomata Norinao, the vassal of Hōjō Ujiyasu, when he had marched on Ōgo castle. Though it had been a humiliating experience, Norinao's hand had been held out to an equal in the hope of forging new alliances. The absence of bloodshed had enabled Hidetsuna to take it and thereby preserve both his honor and his estate. The preservation of the family estate, in turn, had enabled Hidetsuna to remain his own master. Shingen's gesture, despite its magnanimity, was one of pity and offered no hopes of reinstatement. The warlord was too shrewd a tactician to reinstate a deposed vassal of his enemy. What he offered was a sinecure, a token of his admiration and sympathy for the by now aged swordsman, and Hidetsuna realized all too well that by entering Shingen's service he would technically have been reduced to the rank of servant. Nor can the thought of having to serve a man who had been directly responsible for the death of his former master have weighed on his mind favorably. And thus he declined the warlord's offer and expressed his wish to set out on a *musha shugyō*. Shingen, for his part, was not offended. On the contrary, before the three men took their leave, he gave the warrior a further token of his respect. In a short but formal ceremony, fully in keeping with long-standing feudal traditions, he bestowed on Hidetsuna the name of Nobutsuna, a combination of the last character of Hidetsuna and another reading of the first character of Shingen.

It seems that well before he had entered the gates of Takashima castle, Nobutsuna had made up his mind to turn down any such offers as Shingen had just made. It was during his stay at Kiryū castle, during months of painful

reflection on what had been lost and what might still be gained, that the by now fifty-nine-year-old warrior had made up his mind to maintain his independence of spirit and to spend the rest of his life in *musha shugyō*. From now on the rest of his days would be dedicated to the perfection and propagation of the ancient fencing techniques of the Shadow school of fencing that he had learned from his old master, Aisu Ikō, some thirty years before. It had been these ancient techniques, which he had developed into a new style called the Shinkage-ryū, or New Shadow school of fencing, that had thus far saved his life and that would save the lives of those to whom he would hand them down in turn.

It was almost a century before that Nobutsuna's old master had gone through a similarly traumatic experience. Through his example, Ikō had taught him how such an experience need not be the end of the road but rather a new beginning, how it had led him to a new life spent in *musha shugyō* and the advancement of the Shadow school of fencing. And it was this example that Nobutsuna now set himself to emulate as he prepared for his journey—a new turn on the ever meandering road of life.

Toward the end of April 1567, when the spring blossoms were in full bloom and his wounds had sufficiently healed, Nobutsuna took his leave from Kiryū Suketsuna and set out in the company of Hikida Bungorō and Jingo Muneharu. They first headed for the province of Ise. Ise, after all, was the cradle of Aisu Ikō's Shadow school of fencing. The Aisu

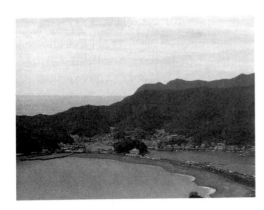

*Gokasho Bay,
the place from
where the ships
of the Aisu clan
once sailed to
raid the main-
land coast*

clan had long had their power base on the Shima Peninsula,
at the southeastern tip of Ise. In the middle of the fifteenth
century, the Aisu clan had abandoned Ichi no Se castle, sit-
uated in a place called Watariai in the heart of the Shima
Peninsula, and moved to a place called Nansei, situated
along the southern coast of the same peninsula. There they
had erected a new castle, called Gokasho, named after the
beautiful bay on whose shores it was built and from where
their ships sailed westward, toward the islands of Shikoku
and Kyushu and even further, to Korea and China.
Nobutsuna's immediate destination, however, was Taki cas-
tle, which was situated on the border of Ise and Yamato
provinces. From Suketsuna, Nobutsuna had received a letter
of introduction to Kitabatake Tomonori, the lord of Taki
castle and the governor of Ise.

Tomonori was a direct descendant of the famous Kitaba-
take Chikafusa, the one-time adviser of Emperor Go-Daigo
and the great strategist behind the loyalist campaign.

According to Suketsuna, the Kitabatake clan was on the rise again. They had forged powerful alliances with neighboring clans, with whose help they had expanded their territory northward, making considerable inroads into the neighboring provinces of Ōmi and Yamashiro.

It was not without reason that Nobutsuna was keen on visiting Tomonori. Though a man of high politics, Tomonori was a renowned swordsman in his own right who had studied the art of fencing under none other than Tsukahara Bokuden. Bokuden had become a legend during his own lifetime. From his early years under the tutelage of his adoptive father, he had gone on to become one of the most celebrated swordsmen of his time, serving as a fencing instructor to three successive Ashikaga shoguns. Precocious in his youth and inclined to ostentation in adulthood, Bokuden's *musha shugyō* was the stuff of legend. In sharp contrast to the solitary peregrinations of the itinerant warrior-monk Nennami Okuyama Jion, Bokuden preferred to travel in company and

Image of Tsukahara Bokuden on one of his many musha shugyō

style. He usually went on horseback, and his average retinue consisted of up to eighty men that, apart from his many acolytes, included cooks, servants, and even female company—a motley crew strangely at odds with the original purpose of the *musha shugyō*. Though at times exaggerated by the chroniclers of his time, Bokuden's fame was not unjustified. He had won nineteen duels, and it was widely believed that he had killed more than two hundred men in the course of thirty-three battles. Some of those battles he had fought on behalf of the Kitabatake clan, but that had been long ago. Bokuden was now a very old man, who had returned to his home village to write his life's work, *Bokuden hyakushū*, a collection of poems in which he sought to distill the essence of the Shintō school of fencing.

Bokuden was not the only fencing master under whom Tomonori had studied. The governor was a man of great refinement, with a keen interest in the martial arts, especially those of archery and swordsmanship. Throughout his life he maintained a wide circle of acquaintances, all experts in their own field who regularly gave demonstrations at one of his clan's many castles.

Summer was already approaching when Nobutsuna, Bungorō, and Muneharu finally arrived at Taki castle. They were warmly welcomed by an amiable but somewhat distracted governor. The Kitabatake clan was being pressed by a certain Oda Nobunaga, yet another young upstart warlord, who hailed from the province of Owari.

It was a potent reminder of how quickly the fortunes of a clan could change in a country immersed in civil war. Things had been set in motion some seven years before, when, at the Battle of Okehazama, Nobunaga had defeated Imagawa Yoshimoto, the warlord of Suruga province and a descendant of Imagawa Sadayo, the man who had subdued Kyushu for the Bakufu during the war between the Southern and Northern courts. Nobunaga had pounced on Imagawa as the latter was passing through Owari province at the head of some twenty thousand men. It had been a splendid and unlikely victory, for Nobunaga had achieved it with no more than three thousand men. It had also been a victory with far-reaching political implications. Imagawa had been on his way to the capital in a serious bid to seize the reins of power for himself. The idea had clearly set Nobunaga thinking, for soon it was rumored that he, too, had set his sights on the capital. Unlike Imagawa, the young upstart from Owari made no secret of his designs, nor that his ultimate ambition was the reunification of the whole of Japan. Indeed, proof of these ambitions was there for all to read, for his seal now carried the motto *tenka fubu,* "rule the whole country by force." Since the Battle of Okehazama, he had been working hard to put these words into practice. In short order he laid siege to Inabayama castle, the stronghold of the Saitō clan. It was a castle of great strategic importance since it overlooked the Mino plain and thus checked any progress westward, toward the provinces of Ōmi and Yamashiro. The province of Ise also bordered on that of Mino, and Tomonori was sure that once Oda had subdued Inabayama

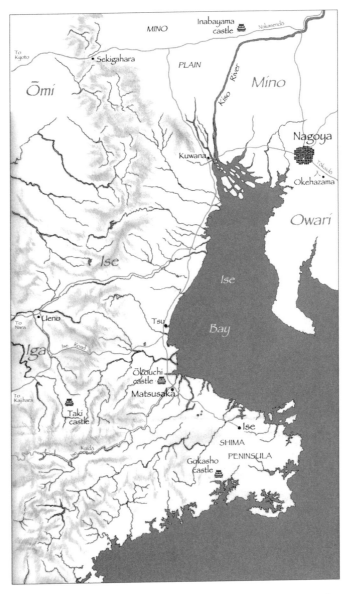

castle, he was bound to try and subdue Ise sooner or later. To counter this ever growing threat, Tomonori was making efforts to raise sufficient forces. It was rumored that Nobunaga had some seventy thousand troops amassed in Mino. Tomonori, by contrast, could only hope to raise about ten thousand. He was therefore preparing to move his headquarters from Taki castle to Ōkouchi castle, in the more southern village of Matsuzaka, where he would stand a better chance of making a successful stand in case he failed to check Nobunaga on the border with Ōmi.

It was clear that the lord of Taki castle was far too preoccupied with this pending threat to be able to entertain his guests. Undoubtedly, he would have welcomed the martial contribution of these three renowned swordsmen, but, then again, no one could say for sure how long Inabayama castle would hold out, nor what Nobunaga's actions would be were he to succeed in subduing the castle. Nor was Nobutsuna, having only recently recovered from the heavy wounds incurred during his escape from Minowa castle, eager to commit himself to the defense of yet another castle—a castle of a warlord to whom he owed no direct allegiance. And thus the men rejoined the Ise path for Ueno in the Yoshino Mountains, and from there toward Nara, the ancient capital of Yamato and home to the famous Kōfuku monastery.

The Kōfuku monastery was the main seat of the Hossō, a powerful Buddhist sect. The monastery itself had a long and checkered history, dating back to the end of the seventh cen-

Reconstruction of the sprawling complex of the Kōfuku monastery

tury, when its first temple complex was erected at Yamanashi to fulfill the dying wish of the powerful Fujiwara Kamatari. Building on the patronage of the Fujiwara clan, the Kōfuku monastery rapidly grew in wealth and power during the succeeding centuries. With the decline of the Fujiwara after the eleventh century, the continuing power of the Hossō sect had often brought it into conflict with the new ruling elite. As in 1180, when the Hossō had supported the Minamoto in their rise against the Taira, a rebellion that had led to the outbreak of the Gempei War. It had also cost the Hossō sect dearly. Taira Shigehara, who had been sent down to deal with the rebellious monks, had ordered his men to make a fire to illuminate the scene of battle as dusk was setting in. That night, however, there blew a fierce wind, which carried the fire to a nearby farmhouse, from where it spread to one of the outbuildings of the monastery. Before long, the flames had enveloped a large part of the Kōfuku monastery and the nearby Tōdai monastery, killing three and a half thousand

people, many of them women and children who had sought refuge from the battle raging outside. Since that time the Hossō sect had lost much of its power to encroaching warlords, but even in Nobutsuna's day the Kōfuku remained one of the largest monasteries of its kind in Japan. It consisted of a vast complex of temples and affiliated buildings that housed several thousand monks, and it still possessed numerous landholdings throughout the province of Yamato.

One of the abbots of the Kōfuku monastery was Hōzōin Kakuzenbō In'ei. In'ei was the chief abbot of the Hōzō temple and a direct descendant of the Nakanomikado, a renowned line of *sōhei*, the warrior monks who had given the Kōfuku and other monasteries like the Enryaku such a notorious name during the preceding centuries. Like his ancestors, In'ei was highly skilled in the art of *sōjutsu*, or spear fighting, an art in which, some years previously, he had founded his own school, the Hōzōin-ryū. He was also adept in the art of swordsmanship, an art he had first acquired under the tutelage

Image of Hōzōin Kakuzenbō In'ei, founder of the Hōzōin school of spear fighting

of the old fencing master Toda Yosaemon, an exponent of
Jion's Nen school of fencing. Always looking to broaden his
martial horizons, In'ei had moved on to acquire other styles of
fencing, including Chōisai's Shintō school of fencing. It is
believed that in his almost pathological quest for new styles
and techniques, the young In'ei had studied under as many as
forty different masters of various weapons, chief among them
the *taitō*, the *yari*, and the *naginata*.

Even after his succession to the position of chief abbot,
In'ei had lost nothing of his original passion for the martial
arts. He organized regular contests, or *shiai*, in which he
could pit his warrior monks against each other in order to
test and hone their skills and thus maintain the defensive
power of his monastery in a time of anarchy. These contests
were intended not only for the warrior monks of the Kōfuku
monastery but were attended also by monks from other
branches of the Hossō sect as far afield as Kyushu. Like the
monasteries of the other great Buddhist sects, the Kōfuku
monastery had a long-standing martial tradition with its own
specific schools of *sōjutsu*. Over the years these gatherings
had grown into massive events lasting for several days and
drawing hundreds of warrior monks from all over Japan. Nor
were these contests dedicated solely to the art of spear fight-
ing. In his undiminished passion to acquaint himself with
new schools of martial arts, In'ei would often invite
renowned martial experts from outside the Buddhist clergy
to participate in contests between different schools of mar-
tial arts, the so-called *taryū shiai*. Participants came from feu-
dal estates on peaceful terms with the Kōfuku monastery,

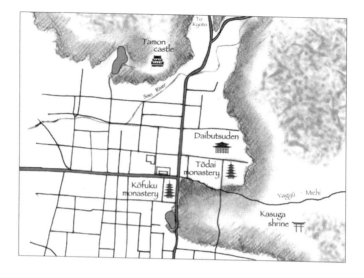

both from within Yamato and from neighboring provinces. Nobutsuna knew of In'ei's thirst for knowledge, how he would jump at the opportunity to acquaint himself with the New Shadow school of fencing, and it was this knowledge that led him and his two companions to take the road to Nara.

When the three swordsmen arrived in Nara toward the end of August 1567, they encountered a town under siege. Thousands of troops had taken up quarters on the premises of the Tōdai monastery. It was only after they had made their way to the Kōfuku monastery and met its abbot that the men were made aware of the recent developments that had led to this state of affairs. In'ei explained how two rivaling Yamato clans, the Miyoshi and the Matsunaga, were vying for supremacy. Hostilities between the two clans had erupted in the first months of 1566. They had begun as spo-

radic clashes but had flared up into a fierce conflagration when, early in 1567, one of the Miyoshi had gone over to the camp of the Matsunaga and taken up residence in Tamon castle, the stronghold of Matsunaga Hisahide, situated on Nara's outskirts. This had prompted the Miyoshi to raise a force of some ten thousand troops and set up camp in the precincts of the Tōdai monastery. Both camps were soon joined by vassal forces from further afield, and before long the whole of Nara had changed into a military war zone. In April, Matsunaga forces had taken up positions at the monastery's southern gate and opened fire on one of its pagodas. More hostilities had followed, and while none of them developed into a full-blown battle, the damage to the monastery was extensive. Four of its age-old buildings had sustained severe damage, while the southern gate with its huge roof had burned down completely. For the present the dust had settled, but it was difficult to predict how things would develop in the coming weeks and months.

The immense southern gate of the Tōdai monastery

175

Despite this precarious state of affairs, the abbot was delighted with the arrival of swordsmen from such distant quarters, so much so that he organized a small *shiai* in their honor. He even sent out word to both camps to send their most accomplished swordsmen to take part in the contest. Many a swordsman responded, including a man called Yagyū Muneyoshi, who hailed from the village of Yagyū, a hamlet situated only a few miles northeast of Nara. Muneyoshi was a Matsunaga vassal, who had taken part in a number of the skirmishes around the Tōdai monastery during the preceding year. The thirty-nine-year-old warrior was a man of considerable repute in Yamato province. He had studied the Shintō school of fencing under Katori Shinjurō, the Ittō schools of fencing under Toda Ittōsai, and was considered the most talented swordsman of the Kinai district. It was on his request for a duel that Nobutsuna pitted Muneyoshi against his nephew, Hikida Bungorō. Bungorō won the contest hands down, very much to everyone's astonishment, not least that

Yagyū Michi, the old road that connects Yagyū with the temple town of Nara

of Muneyoshi, who, deeply impressed by the effectiveness of the Shinkage-ryū, invited the three men to come and stay at Yagyū castle, the family stronghold of the Yagyū clan. It was an invitation the worn and weary travelers were more than willing to accept. Thus it was that, on a hot summer evening in August 1567, the three swordsmen from Kōzuke accompanied the Yamato swordsman along the Yagyū Michi, the narrow road to the old village of Yagyū.

The Yagyū was an old clan, established sometime during the middle of the twelfth century by a certain Yagyū Nagaie. Yagyū castle had been the seat of the Yagyū clan for more than two centuries. It had been built during the first half of the fourteenth century by Yagyū Nagayoshi, ostensibly as a northern outpost in the defense of Go-Daigo's Southern Court in Yoshino. The ground on which the castle stood had of old been the property of the famous and powerful Kasuga shrine in Nara, a shrine that was still patronized by the Yagyū clan. Yagyū castle had survived the eventual fall of the Southern Court. It had equally withstood the tide of anarchy that emanated from the capital in the wake of the Ōnin War—until the summer of 1544, when Tsutsui Junshō, a powerful warlord from Yamato province, had raised an army of a few thousand men and laid siege to Yagyū castle in a drive to expand his territory eastward. At that time, Muneyoshi's father, Ieyoshi, had been forty-eight years old. Muneyoshi himself had only been sixteen years old, yet he had fought bravely alongside his father. It had

177

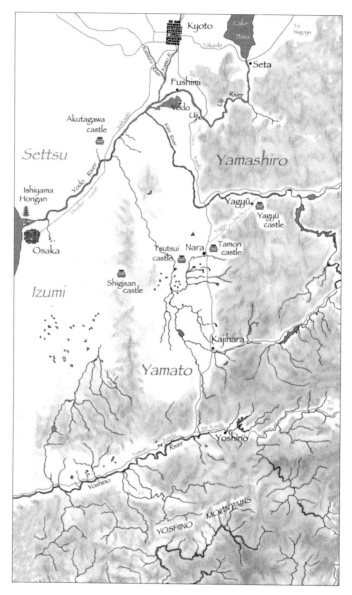

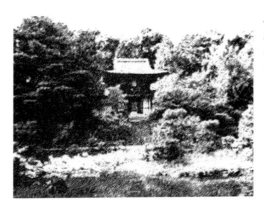

A small temple marks the place where once stood Yagyū castle

been a desperate battle in which the odds were stacked overwhelmingly against the Yagyū, as they had only a few hundred men to defend the castle, and after two days of fighting, the Yagyū had been forced to surrender. They had pledged their allegiance to their new overlord and had served the Tsutsui faithfully until 1560, when the Tsutsui, in turn, had been subdued by the new warlord on the scene, Matsunaga Hisahide, the lord of Tamon castle. From then on the loyalty of the Yagyū to their overlord had become a burden fraught with great moral reservations.

Hisahide originally hailed from Kyoto, where he had made his fortune as a tea merchant. During the 1540s and 1550s, he had attained a position of great influence as a vassal of the same Miyoshi clan he was now fighting. At the time, the Miyoshi clan ruled supreme in the Kinai area, although they originally hailed from the province of Awa on the island of Shikoku. They, too, had risen to power by aligning themselves with a more powerful clan, in their case the Hosokawa,

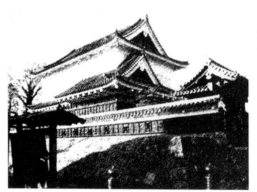

Shōzui castle, the stronghold of the Miyoshi clan

who had become the Bakufu's de facto rulers on the death of Yoshimasa in 1490.

A decade after Yoshimasa's death, at the beginning of the sixteenth century, the Miyoshi had responded to a call from the Hosokawa and embarked with a large force from their stronghold of Shōzui and landed at the port of Sakai. From there they had rapidly widened their sphere of influence, seizing and building castles throughout the Kinai region. In doing so, they had virtually seized control of the capital, and thus the Bakufu, for by this time the Hosokawa, too, were a waning influence. All this was illustrative of the inexorable current of the times, of the ease and ever growing pace with which one warlord deposed another, and of the depth to which the once mighty institution of the Bakufu had sunk. In the same way as the once all-powerful emperor had been reduced to little more than a mascot during the tenth century, cleverly manipulated by powerful shoguns, the shoguns of the sixteenth century had become pawns in the self-seeking

schemes of ruthless warrior clans—clans like the Miyoshi, which, by the time Hisahide had arrived on the stage, was led by Miyoshi Chōkei.

Though a warlord in the standard mold of the Warring States period, Chōkei had a number of redeeming qualities. For one, he was a shrewd and able administrator, influential and widely respected, who, by the time he died in 1564, controlled most of the provinces in the Kinai region. He had thrown himself up as the guardian of the infant shogun Ashikaga Yoshiteru and had become one of the first warlords in the Kinai region to be converted to Christianity by the Portuguese missionary Caspar Vilela, when the latter visited the capital in 1559. One year before his death, when his health was already rapidly declining, Chōkei appointed his eleven-year-old son, Yoshioki, to take over the reins of power. On his appointment, however, the young boy fell ill with an inexplicable affliction to which he succumbed shortly afterward. As the most influential man in Chōkei's retinue, Hisahide

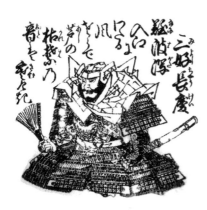

Miyoshi Chōkei, the most powerful warlord in the Kinai region

181

was poised to become the next warlord to control by proxy what remained of the Bakufu. But, as events soon showed, Hisahide had little inclination to follow Chōkei's example, nor was he content with merely ruling by proxy.

In 1565, the year following Chōkei's death, the loyalty of the Yagyū clan toward their new overlord was severely tested. In that year Hisahide conspired with the remaining members of the Miyoshi clan and murdered the shogun, Ashikaga Yoshiteru, along with his wife and mother. It was a foul deed, made all the more contemptible by the constant intimidations to which Hisahide subjected those who had been close and loyal to the shogun. Consequently, only a few monks from the Shōkoku temple were present at the shogun's funeral. This act of brutal treachery also lent ample credence to the stubborn rumor that the young Yoshioki had not died of food poisoning, as Hisahide would have his

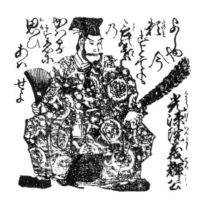

Ashikaga Yoshiteru,
treacherously murdered by
Matsunaga Hisahide

Steps leading up to Hisahide's stronghold are all that remain of the former splendor of Tamon castle

followers believe, but had been poisoned at the hand of one of Hisahide's own henchmen. Yoshioki, in spite of his age, had been a warrior in his father's image, and all who had known his father would have known that he would never have countenanced such a gross act of treachery.

In a lawless world that imposed no constraints on those who lusted for power, men like Matsunaga Hisahide did well for themselves. Tamon castle was a case in point. It had only just been completed, and no cost or labor had been spared. It was of such dazzling splendor that Vilela, the very missionary whom Hisahide had rudely evicted from the region upon Chōkei's death, could not help but acknowledge in his journals the beauty of the seat of power of the very person who had been his nemesis.

Now that castle was under serious threat, for as summer drew to a close, the Miyoshi had managed to gather as many as ten thousand troops in the precincts of the Tōdai monastery. Earlier, in April, Hisahide had left his other

stronghold of Shigisan, situated east of Nara, and taken up residence in Tamon castle. The skirmishes so far had been sporadic, but with the buildup of such large forces, it was only a matter of time before Yagyū Muneyoshi would be called upon to render his services to a lord he could not respect. That call came at the beginning of October 1567, when Hisahide began a large-scale attack on the Miyoshi camp in the Tōdai monastery. The hostilities reached a climax on October 10, when Hisahide's troops opened fire on the troops of Iwanari Tomomichi, a vassal of the Miyoshi who had taken up quarters with a few thousand men on the grounds of the Daibutsuden. This Hall of the Great Buddha was one of the treasures of the Tōdai monastery and, at that time, one of Japan's tallest buildings. Built around the middle of the eighth century, it was considered a national treasure, and every year thousands of pilgrims traveled from every corner of Japan to admire and venerate the forty-eight-foot-high bronze Buddha it housed.

The huge structure of the restored Daibutsuden

Pressed hard by the Matsunaga assault, the Iwanari troops withdrew into the building. Hoping to drive them out, Hisahide ordered his men to fire incendiary arrows into the building. Only few were killed, but the material damage was extensive, for that day the massive roof of the hall went completely up in flames. The heat of the fire was so intense that the head of the Great Buddha melted away. When dawn broke the next day, all that stood were the walls of the building and, amid their charred remains, the decapitated torso of the Great Buddha. Thus the Tōdai monastery suffered its second great calamity in half a millennium. It was a pitiful sight, and in a world longing for peace and quiet, it must have instilled profound spiritual unease, even in the hearts of the least pious of men. Not so, however, in that of Hisahide, who, in giving his impulsive order, had committed his third atrocity, the first being the poisoning of his master, the second the callous murder of a defenseless shogun.

For the Yagyū clan at least, the burning of the Great Buddha was the last straw in a chain of incidents that had made their service to the Matsunaga an increasingly unbearable burden. Shortly after the smoke had cleared, Yagyū Muneyoshi, having consulted with his father and the other members of his clan, decided to forsake the comforts of Yagyū castle and go into hiding. They preferred to lose their worldly possessions and status rather than bear the ignominy of serving Hisahide and the unrightful successors to Chōkei's legacy. Aware that their association with the Yagyū would make them equal outlaws, Nobutsuna and his two companions also chose to go into hiding. And thus, on a cool

and misty October night in 1567, the members of the Yagyū clan and their three guests abandoned Yagyū castle and left Yagyū village, the village that had been the home of their clan for more than four centuries. They made their way into the Yoshino Mountains, where, like the emperor their ancestors had served a century before, they went into hiding, waiting for the moment when the conditions were right to reemerge. The Yagyū knew that sooner or later Hisahide's past was bound to catch up with him and he would have to face the consequences of his unlawful actions.

It was during the next, uncertain year, a year in which the hold on power over Yamato province oscillated between the Matsunaga and the Miyoshi clans, that Nobutsuna found the time to impart to his newfound pupil the knowledge of fencing he had acquired from Aisu Ikō during his stay at Ōgo castle. That had been a quarter of a century ago. Then Nobutsuna had been only thirty-eight years old, one year younger than his present pupil Muneyoshi. Now he himself was an old man, for that year, while he and the Yagyū were in hiding in an unknown hamlet of the Yagyū district, Nobutsuna turned sixty—a great age for a swordsman during the Warring States period. At sixty, he was only ten years younger than Aisu when the latter had initiated him into the secrets of the Shinkage style of fencing. It may well have been this realization that caused Nobutsuna to record his thoughts for posterity, for it was during these dark and uncertain months that Nobutsuna wrote a work called *Kage-*

ryū no mokuroku, a *Catalogue of the Kage School of Fencing*, in which he recorded all the things his old master had taught him so many years ago. It had not only been the technical aspects of his art that Ikō had imparted to his pupil. Like most of the other schools of martial arts, the New Shadow school of fencing encompassed a quasi-philosophical world-view—a view of feudal society and the moral duties of the warrior. Such teachings were often heavily anecdotal in form, uncomplicated tales of trials and tribulations that, though often infused with a mystical dimension, were inspired by real-life experiences that could serve as an example to those to whom they were imparted. So, at least, it had been with the teachings of Ikō and such had been their effect on Nobutsuna. And thus the former pupil now grown old began his work by recounting, albeit in a somewhat sanitized version, that pivotal experience in his teacher's life—an event that had led the pirate to turn his back on the sea and embark on a life of ascetic practice:

Now when Ikō came to a province on the island of Kyushu, there was a shrine called the Great Gongen of Udo. There, he confined himself for thirty-seven days in devout prayer that he might spread his school under the heavens. By thus deeply immersing himself in prayer, he achieved divine knowledge. On the seventeenth day he was again immersed in prayer before the altar when an old man came to him, saying that east from there was a warrior whose name was Sumiyoshi and that he should slay him. Ikō, without further ado, went to the house of Sumiyoshi and stated his purpose.

Sumiyoshi respectfully listened and desired to meet him in duel, upon which Ikō, possessing the secret art attained in meditation, defeated him. By this then his name was known to the four winds and his fame spread throughout the island of Kyushu.

While Nobutsuna was working on his life's work, toward the end of 1568 word reached the Yoshino Mountains that Oda Nobunaga had entered Kyoto. The previous year, only a few months after he had marched into Mino, he had sub-dued Inabayama castle. He had renamed it Gifu castle and made it his new headquarters. Then, in the last weeks of 1567, he had received a missive from Emperor Ōgimachi. In it, the emperor had congratulated the warlord on his remarkable victory and expressed his fervent wish that Nobunaga might now employ his military talents to restore to the throne those properties that had been unrightfully

Oda Nobunaga, the warlord who took the first step toward national unification

Gifu castle,
headquarters of
Oda Nobunaga

confiscated by its enemies. It was the pretext that Nobunaga had been waiting for. A few months later, in the spring of 1568, he had raised a vast army of some sixty thousand men, at the head of which he had begun his march on the capital. In a last effort to break this seemingly inexorable rise to power, the Miyoshi and the Kitabatake had joined forces and made a last stand, hoping to bar the way to the capital. But the gods of war had been squarely on Nobunaga's side. Within a few days he had swept away the opposing forces. With the capital in sight, he had sent for Ashikaga Yoshiaki, the younger brother of the shogun who had died at Hisahide's hands. Aware that he needed to give his claim to the throne as much legitimacy as possible, Nobunaga had given the young boy refuge in his Gifu stronghold, there to remain until the day he could assume his role as puppet ruler. That day came on December 28, 1568. Less than two months after Nobunaga had entered the capital and installed himself in the Bakufu headquarters, he

had his protégé pronounced the fifteenth Ashikaga shogun during a grand ceremony.

Nobunaga's arrival in the capital was to have profound consequences for the fortunes of the power brokers in Yamato province and, by extension, also the fate of smaller players such as the Yagyū clan. Even from the remoteness of Gifu castle, Nobunaga had closely followed the pursuits of the Matsunaga and Miyoshi clans. What he heard had pleased him little. Capable of immense cruelty himself, somehow that cruelty always served an ultimate purpose, whether it was the killing of his own brother because he conspired against him or the rooting out of the Ikkō sect by killing off its offspring. Such logic, however perverted, seemed to be patently absent in the actions of the two rivaling Yamato clans. Especially in Hisahide's case there seemed to be little correlation between the gravity of his objectives and the excesses of his actions—a flaw that led Nobunaga to observe that Hisahide was the kind of man "who has succeeded in perpetrating as many as three outrages without even one accomplishment to his credit."

It must have been this observation that prompted Nobunaga, within only weeks of his arrival in the capital, to dispatch one of his chief vassals, Sakuma Nobumori, to lead a force of ten thousand men into Yamato province to subdue its incessantly feuding warlords. If anything, Nobumori's brief was made only easier by the constant fighting between the two factions. By now the conflict had lasted for the better part of two years, and its wasting effects were beginning to take their toll on both parties.

Following the destruction of the Hall of the Great Buddha, Hisahide had held the upper hand for some time, but his fortunes had taken a change for the worse. Only two months before Nobunaga's arrival in the capital, the Miyoshi had captured Tamon castle and Hisahide had been forced to fall back on his original stronghold of Shigisan castle. From there he was now making overtures to Nobunaga by sending him hostages along with some exquisite Chinaware and a letter in which he welcomed the patronage of his new overlord. At this juncture the Miyoshi held the upper hand, but the continued warring had eroded their strength. In a last attempt to salvage what they had gained, they aligned themselves with the Rokkaku, another clan from the home provinces, which resisted Nobunaga's rule. But one by one the Miyoshi strongholds fell. By 1569 the Miyoshi had been forced to retreat to Akutagawa castle, the clan's headquarters situated halfway between Kyoto and Osaka. Before long even this castle fell before the Nobunaga

A section of Akutagawa castle wall stands derelict and forlorn amid a bamboo grove

191

onslaught. At length the Miyoshi were compelled to retrace the very route their ancestors had followed in their rise to power. Moving in the opposite direction, they embarked from Sakai and crossed the Inland Sea toward their last remaining stronghold, Shōzui castle on the eastern tip of Shikoku island. It was from there that, half a century before, their ancestors had embarked for Sakai in their successful bid to subdue the Kinai region. When it became clear that the plight of the leading warlords in the home provinces was settled, the smaller feudal lords, who had hitherto allied themselves with one of the two main factions, distanced themselves from their former masters and sued for peace.

Few would have realized it at the time, but in subduing the home provinces, Nobunaga had taken the first great step toward Japan's unification. It was to take more than three decades before Nobunaga's vision of a centrally ruled country was realized, and though he would not live to see it, he had laid the foundation for a period of prosperity and peace that would last for more than two centuries.

A period of relative calm now descended on the province of Yamato, and it was during this period, as the tortured populace drew renewed breath, that in the first month of 1569 the Yagyū were visited by a young man called Urabe Nagamatsu, a member of the famous clan whose members served as *hafuribe* at many of Japan's most important shrines. Nagamatsu's clan had been traditionally connected to the Hirano shrine, in the northern district of the capital, and the

Yoshida shrine, closer to the center. It was through the Hirano shrine's close connections with the Kasuga shrine (the shrine patronized by the Yagyū) that Nagamatsu had learned of Nobutsuna's whereabouts, and his own clan's close connections with Iizasa Chōisai (the swordsman under whom Nobutsuna's father had studied) had given the young Nagamatsu the courage to approach the old master with a matter of a very delicate order.

Nagamatsu's father, Kanetomo, was, at the time, the senior official of the two shrines. He had held this dual and taxing post for most of his life, but now he was a frail old man and his increasing physical and mental infirmity had begun to seriously affect the operation of the shrines. Being the oldest son, Nagamatsu was the designated man to take his father's place, but, probably as a result of his condition, his father would not hear of making way for his son and stubbornly persisted in running the shrines himself. It was an impossible state of affairs. The only way Nagamatsu could

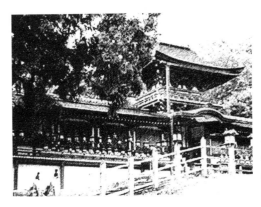

Nara's Kasuga shrine, still patronized by the Yagyū clan

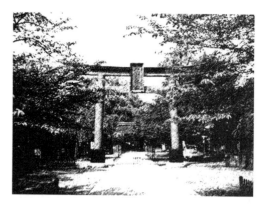

The great torii, *which still guards the entrance to the Hirano shrine*

hope to resolve this predicament was to have his father removed by court order. To secure such an order, he would have to submit a written request. That request, in turn, would have to be accompanied by another document, drafted and signed by a patron of the shrines. Well versed in the history of the two shrines, Nagamatsu knew that, through their descent from the Fujiwara, the Kamiizumi were one of the oldest patrons of the Yoshida and Hirano shrines. With the sponsorship of the old swordsman, he hoped to prevail on Yoshida Kanemigi, the minister in charge of matters relating to Shintoism, to have his father relieved of his function and thereby restore normalcy to the operation of the two shrines and honor to his family. To expedite the submission of his request, he had already won the support of another minister at court, the famous diarist Yamashina Tokitsugu. To the young man's delight, Nobutsuna consented and, that same day, the two men prepared to go up to the capital the next day.

Thus it was that, on the evening of February 2, 1569, Tokitsugu recorded in his diary how he, Urabe Nagamatsu, and the old fencing master Kamiizumi Nobutsuna had visited the residence of Yoshida Kanemigi. And though the diarist failed to record the content of their discussions with Kanemigi, it is clear that, at least for Nobutsuna, matters remained that needed to be addressed, for it was on his request that, on April 28, the three men once again set out to visit Kanemigi, only to find that he was away on business. The same occurred on the following day. It appeared that the ministry of matters relating to Shintoism was an exceedingly busy one, for when the three men visited Kanemigi's residence once more on May 7, they again had to return home without having attained their objective. Over the next three months the three men visited Tokitsugu as many as six times. And it was in the course of these errands that a friendship began to develop between the warrior from Kōzuke and the nobleman from Kyoto. So much at least is borne out by Tokitsugu's diary, which, on May 11 records how Nobutsuna "dropped by for a chat." The brevity of the entry suggests that theirs was a quasi-formal friendship, yet the two men must have enjoyed each other's company, for only a few days later, on May 15, Tokitsugu made a similar entry, although, for that year, it was to be the last time the two men met.

Not until January 5, 1570, did the two men meet again. Nobutsuna had come up to Kyoto to wish his friend a happy New Year. For the swordsman, the year was to be a happy and perhaps the most important one in his long martial

Kamiizumi Nobutsuna at the height of his fame

career. On June 27, the newly installed shogun Ashikaga Yoshiaki raised the sixty-two-year-old swordsman to the rank of Jūshi-i, or Fourth-Level Warrior Follower. It was a singular achievement, for Nobutsuna was the first and last swordsman ever to be appointed to such high rank. The immediate reason for the promotion was the services the old man had rendered to the greater good of the country. But in a society where loyalty was valued above all else, the services Nobutsuna's father had rendered to Nagano Narimasa and Uesugi Norimasa must have been a decisive factor in his promotion, no matter how strained the relation between the Uesugi and the Bakufu had become. Another factor that undoubtedly will have contributed to Nobutsuna's promotion was his new-won friend Tokitsugu. As the official in charge of the budget of the imperial household, Tokitsugu was not directly charged with the conferring of such ranks, yet he may well have recommended his friend for such a promotion, and his favorable impression of Nobutsuna must

almost certainly have influenced his fellow courtiers in their final appraisal of the swordsman. Similarly, it was probably through Tokitsugu's offices that Nobutsuna experienced the crowning moment in his long martial career, when, not much later, he was asked to give a demonstration of the New Shadow school of fencing in the presence of none other than Emperor Ōgimachi himself.

The two friends saw a lot of each other in the course of that auspicious year. In the months immediately before and after his promotion, Nobutsuna visited Tokitsugu regularly to instruct both the latter and his son, Tokitsune, in the art of *senjū*, a martial art of divination that was to form the basis of the later school of *heihō*. For the aging swordsman, it was also a year that brought some leisure. Not long after Nobutsuna's promotion, on July 7, the swordsman and the courtier were invited by the abbot of the Hieizan monastery to climb the mountain on which his monastery was situated. On this occasion the two friends were joined by another

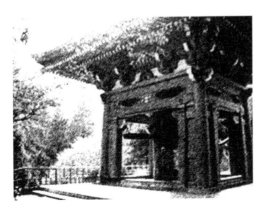

Old bell tower of the Hieizan temple complex

swordsman, Chiaki Gyōbushō, one of Nobunaga's retainers and one-time student of Tsukahara Bokuden. For three nights the three men indulged themselves in the abbot's hospitality, enjoying the rustic comfort of the monastery's ancient buildings amid the scenic beauty of their surroundings. Then, on July 10, the last day of their visit, among the ruins of one of the countless buildings destroyed in the course of the civil war, the two swordsmen gave a demonstration of their skills by way of gratitude to their host.

More than a year had passed since Nobutsuna had come out of hiding. By now the swordsman from Kōzuke had become a celebrated man in the capital and was often called upon to give a demonstration of his superlative fencing skills. Many of these occasions were recorded by the faithful diarist, either because he had personally arranged them or because they had caught his attention, such as on the morning of August 17, when the courtier ran into his friend by accident. It had been a full moon the night before, and the previous evening Tokitsugu had attended a moon-viewing banquet at the residence of a court noble. On his return to the capital the next day, he summoned his rickshaw man to halt at the Shinjū temple, having noticed that a large crowd had gathered in its inner court. To his surprise he saw that the crowd had come to watch his friend giving a demonstration of the New Shadow school of fencing. Here, too, Nobutsuna was in the company of Gyōbushō, as well as one of his old and trusted retainers, Jingo Muneharu.

Contemporary map of the Ishiyama Hongan temple complex (white rectangle) and surrounding area

But this interlude of quiet, however sweet, was not to last. Toward the end of 1570 the Miyoshi returned from the island of Shikoku and began to stir up trouble again in the capital. They were joined by a few thousand warrior monks of the Ikkō sect. Of all the sects that populated Japan's medieval landscape the Ikkō was perhaps the most fanatical and dangerous sect to threaten the authority of centralized power. Compared to similar sects such as the Tendai of Mount Hiei and the Hossō of the Kōfuku monastery, the Ikkō were relative newcomers. It had its power base in the distant province of Kaga on the Japan Sea. Its headquarters, however, were situated in Osaka, where, through the offices of the merchants of the nearby seaside port of Sakai, the contributions of the Kaga sectarians poured in steadily. Largely on the strength of these funds, the Ikkō had erected a vast complex of temples and fortifications at a place called Ishiyama, a group of islands at the confluence of the Yodo, Neya, and Hirano rivers. Like the monasteries on Mount

Hiei and in Nara, the defenses of the Ishiyama Hongan temple, as the complex was called, were manned by vast garrisons of *sōhei*. Reflecting the progressive character of the Ikkō sect, its *sōhei* were of a new brand of warrior, armed with the type of muskets that had been introduced into Japan by the Portuguese a few decades earlier. The monastery even had its own foundry, which churned out these new and powerful tools of warfare in great quantities. Consequently, the *sōhei* who had joined the Miyoshi in the capital caused a great number of casualties among Nobunaga's troops, most of whom were still armed with traditional Japanese arms.

Faced with this perennial and intractable enemy, Nobunaga decided to take drastic action and forever rid his country of this scourge. In the summer of 1571 he attacked both the headquarters of the Tendai sect on Mount Hiei and that of the Ikkō sect at Ishiyama. The *sōhei* of Mount Hiei were taken by complete surprise. They offered no resistance and surrendered. But Nobunaga showed no

Contemporary illustration of the Ishiyama Hongan temple

*Today, the for-
mer Ikkō strong-
hold is the site of
Osaka castle*

mercy. All the inhabitants of Mount Hiei, including the women and children, were put to the sword. Then he set fire to all the buildings. At the end of the day the whole mountain seemed on fire, and the water that came from the mountain was crimson with blood. Nobunaga's troops were less successful at Ishiyama. Hearing of the horrible massacre at Mount Hiei, the warrior monks of the Ishiyama Hongan monastery put up a fierce resistance. Here they had the terrain on their side, for the islands on which their strongholds were situated were difficult to reach and thus easy to defend.

With every blow sustained by Nobunaga's troops, the other warlords who had an eye on the capital saw their chances grow. Even Matsunaga Hisahide had buried his differences with the Miyoshi and was plotting Nobunaga's overthrow. Perhaps the greatest threat to Nobunaga's hold on power at this time was posed by Takeda Shingen, that old fox from the north. Like the cunning Hisahide, Shingen, too, had initially sided with Nobunaga, mainly to deal more

effectively with more immediate rivals such as Uesugi
Kenshin and Hōjō Ujiyasu. One year after the outbreak of
hostilities in the capital, however, Ujiyasu died and his suc-
cessor, Ujimasa, reached a settlement with Shingen. Shingen
now had his hands free to deal with Nobunaga.

The only thing that kept him from immediately marching
on the capital was the threat of being attacked from the rear
by his old enemy Kenshin. To counter this threat, he needed
a means to keep Kenshin preoccupied, and what better way
than by allying himself with the Ikkō sectarians in Kaga, the
same fanatics who had so effectively managed to preoccupy
no lesser men than Nobunaga?

Missives were duly sent to Ishiyama, and before long
Shingen had signed a pact with Kōsa, the monastery's chief
abbot. Finally, in November 1572, with all the obstacles out

of the way, he raised a force of thirty thousand men and began to march westward, following the course of the Tenryū River for a hundred miles, down to its lower reaches on Japan's eastern coast, where it poured into the Pacific Ocean. There, on a plain called Mikatagahara, he joined battle with Nobunaga, who had been joined by forces of a young local warlord by the name of Tokugawa Ieyasu, the lord of Hikuma castle. Shingen nevertheless gained a resounding victory and Ieyasu had to run for his life. Nobunaga sought to reach a settlement, but, with the capital in his sights, Shingen would not hear of it. Instead he entered into negotiations with Ashikaga Yoshiaki, who had grown dissatisfied with the subordinate role he had been forced to play in Nobunaga's plans. It seemed that after all his initial successes the net was finally closing around Nobunaga. Then, in the spring of 1573, news arrived in Nobunaga's camp that Shingen had died. He had fallen ill while still encamped at Mikawa and had died on his way home. Vexed by Yoshiaki's

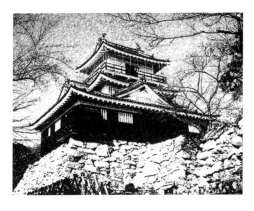

Hikuma castle, headquarters of Tokugawa Ieyasu

betrayal, Nobunaga immediately returned to the capital and burned down Nijō castle, the residence he had built especially for the shogun only a few years before. Yoshiaki was sent into exile, formally bringing to an end the reign of the Muromachi Bakufu, a reign that had already ended more than a century before in all but name.

With his chief military rival out of the way, Nobunaga now turned his full attention to the destruction of the Ikkō sect. The first great showdown came in the spring of 1574 when Nobunaga moved against a fortified stronghold on the island of Nagashima, situated in the delta of the Kiso River in the Bay of Ise. Some twenty thousand Ikkō followers had ensconced themselves in the stronghold, and even after two major assaults in as many months, Nobunaga's troops failed to bring to heel the warrior monks, who were now concen-

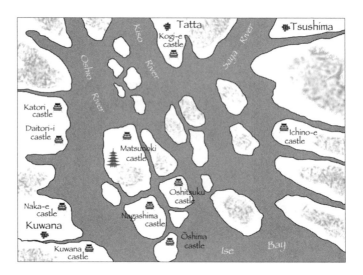

trated in two strongholds. Yet with each day the plight of the defenders was growing more critical. Surrounded by Nobunaga's troops on land and by Ise pirates from the sea, they were cut off from all support, so that by the end of August, many were dying of starvation. Seeing the futility of their struggle, the monks decided to give up and sue for peace. Yet Nobunaga, who only two years earlier had sought to do the same when he himself felt threatened by a mightier opponent, was immalleable. In a final assault, early in October, he ordered his men to set fire to the two remaining buildings, thus killing all their occupants: men, women, and children alike. Then he turned his attention to the monks of the Ishiyama Hongan monastery. But here he had more trouble, for the chief abbot Kōsa had conveniently formed an alliance with Mōri Terumoto, the leader of an old seafaring clan, whose ships supplied his stronghold with all they needed in food and clothing.

It took another five years before Nobunaga finally managed to crush the resistance of the Ikkō sect. It was a veritable war of attrition in which both parties sustained severe losses. Finally, in April 1580, having deliberated at length with his military advisers and been urged to do so in a letter of advice from none other than the emperor, Kōsa departed from Ishiyama. Only a few weeks later the fortress surrendered. Nobunaga had achieved his goal. Never again were sectarians to rise in such numbers against the rule of centralized power, their militant spell over the populace for once and always broken. In achieving his goal, Nobunaga had exacted a terrible toll on his country's religious community.

Yama yama, tani tani (over every hill and through every valley) he had pursued the hapless survivors from Nagashima who had managed to escape, until not one of them was left alive. By the end of his campaign against the major religious sects, as many as twenty thousand followers had perished, while hundreds of ancient monasteries, together with all their treasured artifacts and libraries, had gone up in flames.

By then the curtain had also fallen on Matsunaga Hisahide. Having reconciled himself to his former enemies, the Miyoshi, he had risen against Nobunaga after the latter had granted governorship over Yamato province to the Tsutsui (the Yagyū's former overlords); the man who had made his career with betrayal had himself felt betrayed. The final reckoning for his short career of treachery and deceit came on October 10, 1577, when, encircled by Nobunaga's troops, he was left with two options, either surrender and be exe-

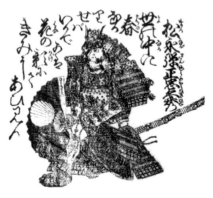

Matsunaga Hisahide, whose career was built on treachery and betrayal

206

*View from
Shigisan castle*

cuted or commit suicide. Choosing the latter, he withdrew
to the main tower of Shigisan castle. There, among his vast
collection of precious bronzes and ceramics, he detonated a
cast-iron tea kiln filled with gunpowder. The kiln had been
the former tea merchant's favorite article. It is believed that
in his last moments on earth, he had hugged his cherished
possession close to his chest, for the force of the explosion
tore off his head, which was duly delivered to Nobunaga for
inspection. It was ten years to the day that Hisahide had
decapitated the Great Buddha of the Tōdai monastery, and
the thunderous roar that rolled through the Yamato moun-
tains seemed to simultaneously echo the ignoble end of an
ignoble career and to herald the dawn of a new beginning.

Hisahide had no heirs, so that with his death the
Matsunaga clan had been extinguished. With Hisahide's
death and the return of the Tsutsui, the Yagyū found them-
selves once more in the patronage of their former overlord.
Under the Tsutsui they were to play a prominent role in the

last decisive campaigns to unify the country. In those campaigns, it was the exploits of Munenori, born to Muneyoshi in 1571, that were to spectacularly boost the fortunes of the Yagyū clan. Munenori rose from common retainer to *ōmetsuke*, or inspector general. The crowning moment in Munenori's military career—and in the fortunes of the Yagyū clan—came in 1636, when he was raised to the position of *fudai*, or vassal, daimyo, with a fiefdom of ten thousand *koku*. By then Munenori had been a fencing instructor to two successive shoguns. The Yagyū had developed their own style from Nobutsuna's Shinkage school of swordsmanship, a style they called the Yagyū Shinkage school of fencing. Yet the success of their school—perhaps even that of their clan—would have been unthinkable without Nobutsuna's contribution. By reaching such exalted heights, Munenori was able to repay part of his family's debt of gratitude, for with his rise to fame, so the Shinkage-ryū gained in popularity, until, by the middle of the seventeenth century, it shared the stage with Itō Ittōsai's Ittō-ryū and Chōisai's Shintō-ryū as one of the three most popular schools of fencing during the Edo period.

Long before Munenori began his first practice in the art of fencing, the man who had imparted his art to the Yagyū had departed from Yagyū castle. In fact, it was in the same year that Munenori was born that Nobutsuna had made up his mind to leave the village where he had spent some of the most pleasant years of his life. In the spring of 1571, seeing

his school of fencing saved for posterity and sensing that his end was drawing near, Nobutsuna made up his mind to return to the Kantō, the region where he had spent his youth and where he had his roots. Given his celebrity among the courtiers in the capital and all the honors that had been bestowed on him over the last year, it must have been a difficult decision. This time, he would also have to travel alone, for Hikida Bungorō and Jingo Muneharu, the two young swordsmen who had accompanied him on his journey thither and who had shared in his successes following their arrival, had decided to stay on and make a name for themselves as fencing instructors.

As things stood, Nobutsuna had precious little to return home to. Kiryū Suketsuna, the warlord who had received him with such hospitality after the fall of Minowa castle, had died the previous year. His adopted successor, Kiryū Chikatsuna, was unknown to Nobutsuna; he came from the Masatsuna clan, which had been sworn enemies of Uesugi Kenshin. Worse still, shortly after Suketsuna's death, Chikatsuna had taken on the Satomi, the very clan that had claimed the life of Nobutsuna's elder son. This made Kiryū castle a dangerous place to be for an old fencing master who was looking for a place to spend his last few years in peace. It left him with no one to turn to in the Kantō region, for with the death of Narimori in the battle for Minowa castle, the Kōzuke branch of the Nagano—the clan that Nobutsuna had served faithfully for most of his life—had also come to an end. It was the fate of so many feudal houses during the Warring States period, and the fate, too, of the Kamiizumi clan.

Aizu Wakamatsu castle, seat of power of Uesugi Kagekatsu

Shortly before he had set out for the capital, Nobutsuna's one surviving son, Norimoto, had entered the service of Uesugi Kagekatsu, the lord of Aizu Wakamatsu castle, situated in the northern regions of Mutsu province. Norimoto had done well for himself, for by now he had been adopted into the clan. He had been granted a small estate on the grounds of Aizu Wakamatsu castle with a yield of three thousand *koku*. Norimoto's estate must have been of considerable dimensions. One *koku* of rice was sufficient to support a man for a year, so that the yield of his estate would have been sufficient to support an army of several hundred men. For the old Nobutsuna, the success of his son was both a solace and a source of sadness, for with the death of Hidetane and the adoption of Norimoto, combined with the loss of his estate to Takeda Shingen in 1567, the old warrior well knew that he could not hope to see the Kamiizumi name survive.

Thus it was that, on July 21, 1571, Nobutsuna paid his friend at court a last visit. This time it was the swordsman

himself who required a favor from the courtier. Tokitsugu was well and widely connected, and with a personal reference from him, it would be a less daunting task for the old swordsman to find a place in the Kantō region to which he could retire. Tokitsugu willingly obliged and furnished his friend with a letter of introduction to the Shimōsa warlord Yūki Harutomo, the master of Yūki castle and a distant descendant of the loyalist Yūki Munehiro.

Very little is known about Nobutsuna's last few years. What is certain is that, like Chōisai, the old Nobutsuna, too, continued to practice his particular style of fencing in old age, instructing Harutomo's clansmen in the New Shadow school of fencing and giving frequent demonstrations for Harutomo and his important visitors. He was by now a very old man, and, though his techniques still revealed his genius, their execution lacked the vigor that had kept the audiences in the capital spellbound even when the swordsman was already in his sixties. Eventually, even those

The old bridge to Yūki castle, its only remains

Falls of Fudō, a site of scenic beauty that still attracts many a pilgrim today

superior techniques could not compensate for the warrior's waning powers. Old, frail, and increasingly burdened by a sense of inadequacy, Nobutsuna once again chose to forsake the hospitality of a benefactor and leave Yūki castle. He traveled back to his very roots, the village of Kamiizumi and the place where he wanted to die. He built there a small Buddhist temple and named it Sairin. During his last years he could often be seen climbing the mountain at whose foot it had all begun. There, against the backdrop of the falls of Fudō, he would spend hours in quiet contemplation, reflecting on a life that had known many ups and downs.

Nobutsuna died early in 1577, shortly after conducting a Buddhist ceremony to commemorate the thirteenth anniversary of the death of his elder son, Hidetane. His remains were buried in the grounds of the Sairin temple. In accordance with Japanese tradition, he was given the posthumous name of Kamiizumi Ise no Kami, the name by which he is still known by his followers today. Although the

great swordsman had departed forever, his memory and his style of fencing lived on as the Shinkage-ryū, the New Shadow school of fencing. It lived on through the teachings of the two retainers who had accompanied him on his journey to the capital, his trusty vassals Jingo Muneharu and Hikida Bungorō. The latter played a particularly important role in the propagation of the Shinkage school. Following Nobutsuna's departure from Kyoto, Bungorō had gone on to become a fencing instructor of great repute, serving famous warlords such as Hosokawa Fujitaka and Tokugawa Ieyasu. Yet the chief role in the transmission of Nobutsuna's heritage was reserved for the Yagyū clan. It was their rise to fame, their prominence throughout the Edo period, and the longevity of their clan that ensured the survival of Nobutsuna's school of fencing up to the present day.

FAMOUS JAPANESE SWORDSMEN

PRINCIPAL FIGURES IN THIS CHAPTER

Aisu Ikō:	Warrior from Ise. Founder of the Kage no Ryū, under whom Nobutsuna studied during his stay at Ōta castle.
Aisu Koshichirō:	Son of Aisu Ikō.
Ashikaga Yoshiaki:	Fifteenth Muromachi shogun. Protégé of Oda Nobunaga; sent into exile after his secret overtures to Takeda Shingen.
Ashikaga Yoshiteru:	Thirteenth Muromachi shogun, who was assasinated by Matsunaga Hisahide.
Fujiwara Hidesato:	Distant ancestor of Nobutsuna and the man who routed Taira Masakado.
Hikida Bungorō:	Relative and vassal of Nobutsuna. One of the two men who escaped from Minowa castle with Nobutsuna and later joined him on his journey to the capital.
Hōjō Sōun:	Warlord from Izu. Leader of the Hōjō, who conquered most of Sagami.
Hōjō Tsunashige:	Hōjō general under whom Kamiizumi Hidetane died at the battle at Kōnodai.
Hōjō Ujitsuna:	Son of Hōjō Sōun and the Hōjō leader who conquered most of Musashi.
Hōjō Ujiyasu:	Son of Hōjō Ujitsuna and the Hōjō leader who defeated the Uesugi forces in the defense of Kawagoe castle.
Hōzōin In'ei:	Chief abbot of the Kōfuku monastery. Practitioner of spear fighting and the man who organized a fencing contest for Nobutsuna and his companions.
Inomata Norinao:	Vassal of Hōjō Ujiyasu and the man who took Ōgo castle.

Ise Shinkurō: See Hōjō Sōun.

Jingo Muneharu: Vassal of Nobutsuna. One of the two men who escaped from Minowa castle with Nobutsuna and later joined him on his journey to the capital.

Kamiizumi Hidetane: Son of Nobutsuna who died under Hōjō Tsunashige in the battle at Kōnodai.

Kamiizumi Hidetsugu: Father of Nobutsuna and lord of Ōgo castle.

Kamiizumi Norimoto: Son of Nobutsuna who entered the service of the Mutsu warlord Uesugi Kagekatsu, lord of Aizu Wakamatsu castle.

Kamiizumi Yoshihide: Descendant of Ōgo Shigetoshi and founder of the Kamiizumi clan.

Kiryū Suketsuna: Lord of Kiryū castle. The man who gave shelter to Hidetsuna and his companions following the fall of Minowa castle.

Kitabatake Tomonori: Governor of Ise. The man who welcomed Nobutsuna and his companions at Taki castle.

Kōsa: The chief abbot of the Ishiyama Hongan monastery.

Matsunaga Hisahide: Warlord from Yamato and lord of Tamon castle.

Miyoshi Chōkei: Yamato warlord and leader of the Miyoshi clan. A Christian convert, he was the guardian of Shogun Ashikaga Yoshiteru.

Miyoshi Yoshioki: Son of Miyoshi Chōkei and appointed successor to Chōkei, he died at the age of eleven, probably poisoned by Matsunaga Hisahide.

Nagano Narimasa: Lord of Minowa castle and vassal of Uesugi Norimasa.

Nagano Narimori:	Son of Nagano Narimasa and lord of Minowa castle, who died in the siege of his castle by Takeda Shingen.
Nagano Nobunari:	Father of Nagano Narimasa.
Nagao Tamekage:	Warlord from Echigo. The man who supported the Yamanouchi in their conflict with the Ōgigayatsu line of the Uesugi.
Nagao Terutora:	See Uesugi Kenshin.
Naitō Masatoyo:	Vassal of Takeda Shingen and new lord of Minowa castle.
Oda Nobunaga:	Warlord from Owari. The first of Japan's three great unifiers.
Ōgo Shigetoshi:	Founder of the Ōgo clan.
Ōta Dōkan:	Vassal of the Ōgigayatsu and architect of the castles of Edo, Iwatsuki, and Kawagoe.
Satake Yoshiatsu:	Warlord from Hitachi. Lord of Ōta castle and the lord whom Nobutsuna served during his apprenticeship with Aisu Ikō.
Satake Yoshimoto:	Brother and unsuccessful rival of Satake Yoshiatsu in the contest for leadership of the Satake clan.
Takeda Shingen:	Warlord from Kai and main rival of Uesugi Kenshin. The man who took Minowa castle.
Tawara no Tōta:	See Fujiwara Hidesato.
Tsutsui Junshō:	Yamato warlord to whom the Yagyū pledged allegiance after he had subdued Yagyū castle.
Uesugi Akisada:	Uesugi constable in Echigo, removed by Nagao Tamekage in his rise to power.
Uesugi Akizane:	Leader of the Yamanouchi line of the Uesugi.

Uesugi Kagekatsu:	Warlord from Mutsu. Lord of Aizu Wakamatsu castle, whose service Nobutsuna's son, Norimoto, entered.
Uesugi Kenshin:	Warlord from Echigo and main rival of Takeda Shingen. The son of Nagao Tamekage and the man who offered refuge to Uesugi Norimasa.
Uesugi Norimasa:	Leader of the Yamanouchi branch of the Uesugi and lord of Hirai castle, who was defeated by Hōjō Ujiyasu and forced to flee to Echigo.
Uesugi Tomosada:	Leader of the Ōgigayatsu branch of the Uesugi, who fell during the siege of Kawagoe castle.
Urabe Nagamatsu:	Young shrine official from the Hirano shrine who sought Nobutsuna's help in having his father removed from his post.
Wada Norishige:	Lord of Takasaki castle. Longtime ally of the Uesugi, who went over to the side of Takeda Shingen.
Yagyū Ieyoshi:	Father of Yagyū Muneyoshi.
Yagyū Munenori:	Son of Yagyū Muneyoshi and leader of the Yagyū clan; fencing instructor to two successive shoguns.
Yagyū Muneyoshi:	Leader of the Yagyū clan and lord of Yagyū castle. Vassal of Matsunaga Hisahide and the man who became Nobutsuna's pupil after he had lost a contest with Hikida Bungorō.
Yagyū Nagaie:	Founder of the Yagyū clan.
Yagyū Nagayoshi:	Leader of the Yagyū clan. The man who built Yagyū castle.

Yamashina Tokitsugu: Minister at the imperial court. Friend of Nobutsuna and the man who recorded Nobustuna's activities in his diary.

Yūki Harutomo: Warlord from Shimōsa. Lord of Yūki castle, in whose service Nobutsuna spent some of his last years.

OLD PROVINCES

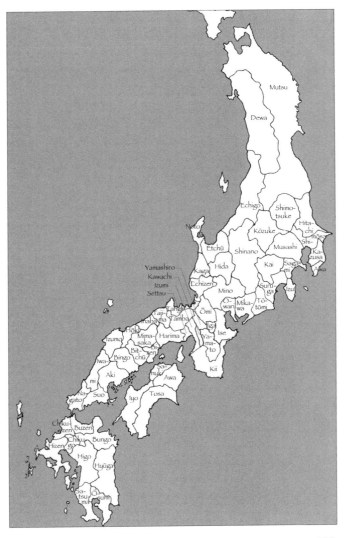

Mutsu

Dewa

Echigo

Shimo-tsuke

Noto

Kōzuke

Hita-chi

Etchū

Shinano

Musashi

Shi-mōsa

Ka-zusa

Yamashiro

Kaga

Hida

Kai

Saga-mi

Awa

Kawachi

Echizen

Suru-ga

Izumi

Mino

Izu

Settsu

Ō-wari

Mika-wa

Tō-tōmi

Taji-ma

Tango

Inaba

Tamba

Ōmi

Hōki

Iga

Ise

Izumo

Mima-saka

Harima

Ya-ma-to

Bit-chū

Bizen

Iwa-mi

Bingo

Sa-nuki

Aki

Awa

Kii

Na-gato

Suō

Iyo

Tosa

Chiku-zen

Buzen

Chiku-go

Hizen

Bungo

Higo

Hyūga

Sa-tsu-ma

Ō-sumi

OLD PROVINCES AND THEIR MODERN EQUIVALENTS

Aki:	Hiroshima	Kazusa:	Chiba
Awa:	Tokushima	Kii:	Wakayama
Bingo:	Hiroshima	Kōzuke:	Gunma
Bitchū:	Okayama	Mikawa:	Aichi
Bungo:	Ōita	Mimasaka:	Okayama
Buzen:	Fukuoka	Mino:	Gifu
Chikugo:	Fukuoka	Musashi:	Saitama and Tokyo
Chikuzen:	Fukuoka	Mutsu:	Aomori
Dewa:	Yamagata, Akita	Nagato:	Yamaguchi
Echigo:	Niigata	Noto:	Ishikawa
Echizen:	Fukui	Ōmi:	Shiga
Etchū:	Fukuyama	Ōsumi:	Kagoshima
Harima:	Hyōgo	Owari:	Aichi
Hida:	Gifu	Sagami:	Kanagawa
Higo:	Kumamoto	Sanuki:	Kagawa
Hitachi:	Ibaraki	Satsuma:	Kagoshima
Hizen:	Nagasaki	Settsu:	Osaka
Hōki:	Tottori	Shimōsa:	Chiba
Hyūga:	Miyazaki	Shinano:	Nagano
Iga:	Mie	Suō:	Yamaguchi
Inaba:	Tottori	Suruga:	Shizuoka
Ise:	Mie	Tajima:	Hyōgo
Iwami:	Shimane	Tamba:	Kyoto
Iyo:	Ehime	Tango:	Kyoto
Izu:	Shizuoka	Tosa:	Kōchi
Izumi:	Osaka	Tōtōmi:	Shizuoka
Izumo:	Shimane	Wakasa:	Fukui
Kaga:	Ishikawa	Yamashiro:	Kyoto
Kai:	Yamanashi	Yamato:	Nara
Kawachi:	Osaka		

CASTLES, SHRINES, AND TEMPLES

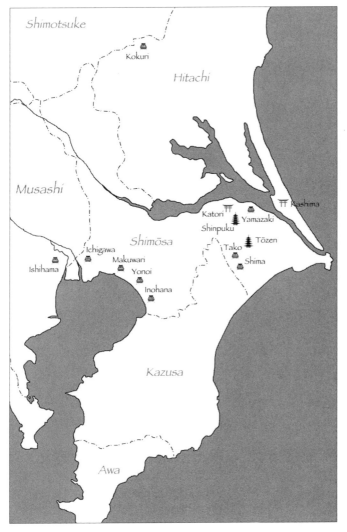

Shimotsuke

Kokuri

Hitachi

Musashi

Katori

Shinpuku

Yamazaki

Kashima

Tako

Tōzen

Shimōsa

Ichigawa

Ishihama

Makuwari

Yonoi

Shima

Inohana

Kazusa

Awa

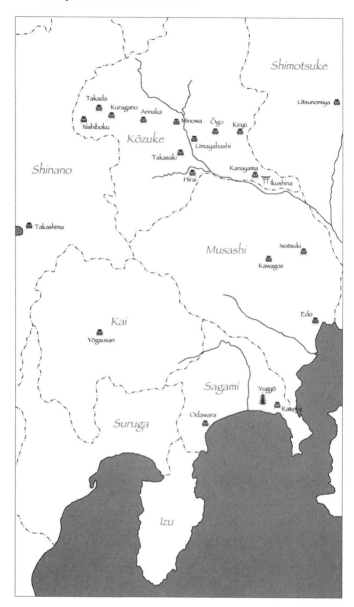

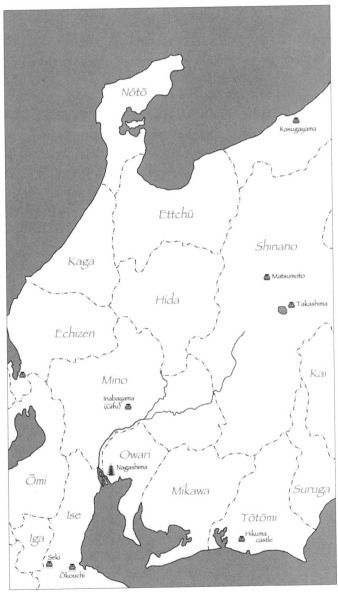

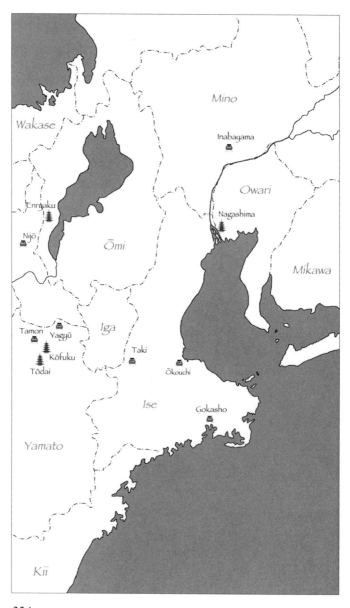

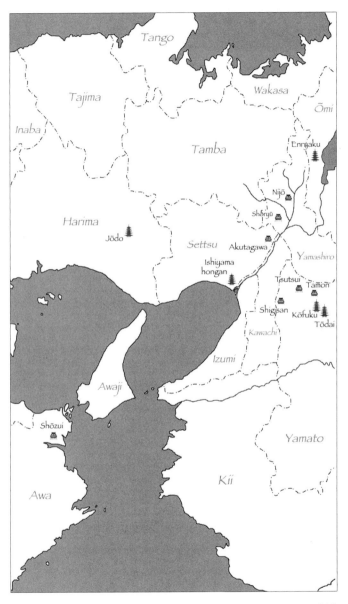

HISTORICAL PERIODS

JAPAN

Nara	710–94
Heian	794–1185
Kamakura	1185–1333
Muromachi	1333–1568
Momoyama	1568–1600
Tokugawa	1600–1868

CHINA

Han	202 BC–AD 220
Three Kingdoms	221–65
Six Dynasties	265–581
Sui	581–618
Tang	618–906
Five Dynasties	907–60
Northern Song	960–1127
Southern Song	1127–1279
Yuan	1271–1368
Ming	1368–1644
Qing	1644–1911

PERIODS OF MILITARY RULE

Kamakura Bakufu	1185–1333
Muromachi Bakufu (Ashikaga Bakufu)	1333–1568
Edo Bakufu (Tokugawa Bakufu)	1603–1867

BATTLES AND REBELLIONS

BATTLES

Battle of Bubaigawara:	1333
Battle of Tegoshigawara:	1335
Battle of Takenoshita:	1335
Battle of Katasegawa:	1336
Battle of Minatogawa:	1336
Battle of Kanagasaki castle:	1337
Battle of Kuromaru castle:	1338
Battle of Seki castle:	1342–43
Battle of Ose:	1538
Battle of Kawagoe castle:	1546
Battles of Kawanakajima:	1553–61
Battle of Okehazama:	1560
Battle of Kōnodai:	1564
Battle of Minowa castle:	1567
Battle of Mikatagahara:	1572
Battle of Nagashima:	1574

REBELLIONS

Masakado rebellion:	940
Tadatsune rebellion:	1027
First Mutsu rebellion:	1051–62
Second Mutsu rebellion:	1083–87
Hōgen rebellion:	1156
Heiji rebellion:	1159

GLOSSARY

ashigaru:	Type of foot soldier that came into its own during the Ōnin War, when large-scale head-on encounters in the open made way for street fighting by stealth.
bokutō:	Wooden sword used for practice.
budō:	Literally, "martial way" but more generally translated as "martial arts." A late medieval term representative of a comprehensive martial philosophy and, as such, closely related to the term *bushidō*, or the "way of the warrior."
dōjō:	Hall with a smooth wooden floor or covered with mats for the practice of martial arts.
gekokujō:	Term used to describe the overthrow of higher military classes by the lower; literally, "the lower conquering the upper."
hafuribe:	Hereditary shrine officials.
heihō:	Art or method of warfare.
honmaru:	Innermost keep, or donjon, of a typical medieval Japanese castle.
ikki:	Term that originally merely denoted joint or concerted action, but during the middle ages became synonymous with uprisings of local warriors and peasants.
kami:	Indigenous dieties.
kanbe:	Limited group of families whose members were historically attached to a Shinto shrine.
kebiishi:	Imperial police or officers attached to the Kebiishi Dokoro, an imperial office establisehd in 816 and charged with the responsibilities of policing and administering justice.

koku: Medieval unit of measurement. One *koku* is approximately the same as 180 liters.

mappō: Buddhist concept that holds that the hardships suffered by the present generation are a retribution for the failure of former generations to uphold Buddhist law.

matsuri: Traditional Shinto festival honoring ancestral dieties.

musha shugyō: Literally, "warrior training" but in the context of *budō*, the old practice of ascetic self-discipline that goes back to the ancient traditions of the mysterious *yamabushi*, or mountain monks.

mutōtori: Fencing technique first developed by Aisu Ikō in which one disarms one's opponent without the use of one's own sword.

naginata: Pole sword.

okugi: Innermost secrets of an art or craft.

ōmetsuke: Inspector general.

senjū: Ancient Chinese art of martial divination.

sōhei: Warrior monks of the great Buddhist temples.

sōjutsu: Art of fighting with a halberd.

taitō: Long sword.

taryū shiai: Literally, "contest of different schools," and used to refer to a duel between two swordsmen.

tsuitōshi: General of punitive expedition for quelling a revolt.

wakō: Japanese pirates who pillaged the coasts of China and Korea during the middle ages.

yamabushi: Reclusive mountain monks of the Japanese Alps, who practiced austerities in the harsh environment of the mountains in order to attain holy or superhuman powers.

yari: Spear or lance.

BIBLIOGRAPHY

ENGLISH SOURCES

Mason, R. H. P., and J. G. Caiger. *A History of Japan.* Tokyo, 1972.
McCullough, Helen Craig, trans. *The Taiheiki.* Boston, 1959.
——, trans. *The Tale of the Heike.* Stanford, 1988.
Morris, Ivan. *The Nobility of Failure.* Oxford, 1964.
Sansom, George. *A History of Japan.* Vols. 1–3. Tokyo, 1963.
Sato Hiroaki. *Legends of the Samurai.* New York, 1995.
Turnbull, S. R. *The Samurai.* New York, 1977.
Varley, Paul. *The Ōnin War.* New York, 1967.
——. *Warriors of Japan.* Honolulu, 1994.

JAPANESE SOURCES

Abe Takeshi and Nishimura Keiko. *Senkoku jinmei jiten.* Tokyo, 1990.
Fukuda Akira. *Chūsei katarimono bungei.* Tokyo, 1981.
Gotō Tanji and Kamada Kisaburō. *Taiheiki.* Vols. 1–3. Tokyo, 1962.
Hioki Shōichi. *Nihon sōhei kenkyū.* Tokyo, 1972.
Hirata Toshiharu. *Sōhei to bushi.* Tokyo, 1965.
Hirotani Yūtarō. *Nihon kendō shiryō.* Tokyo, 1943.
Ichiko Teiji, ed. *Heike monogatari.* Vols. 1 and 2. Tokyo, 1975.
Ishii Susumi. *Kamakura bushi no jisshō.* Tokyo, 1985.
Kaionji Chōgorō. *Bushō retsuden.* Vols. 1–6. Tokyo, 1965.
Kajiwara Masaaki, trans. *Shōmonki.* Vols. 1 and 2. Tokyo, 1976.
Katsuno Ryūshin. *Sōhei.* Tokyo, 1956.
Kitagawa Hiroshi. *Gunkimono no keifu.* Kyoto, 1985.
Kuwata Tadachika. *Chosaku-shū.* Vols. 1–10. Tokyo. 1980.
——. *Nihon no kengō.* Vols. 1–5. Tokyo, 1984.

Maki Hidehiko. *Kengō zenshi.* Tokyo, 2003.

Matsumura Hiroshi. *Rekishi monogatari.* Tokyo, 1979.

Nagashima Fukutarō. *Ōnin no ran.* Tokyo, 1968.

Nagazumi Yasuaki. *Gunki monogatari no sekai.* Tokyo, 1978.

———. *Taiheiki no sekai.* Tokyo, 1987.

Nagazumi Yasuaki and Shimada Isao. *Hōgen monogatari.* Tokyo, 1961.

Nakamura Akira. *Shinkage-ryū Kamiizumi Nobutsuna.* Tokyo, 2004.

Nanjō Norio. *Nihon no meijō, kojō jiten.* Tokyo, 1997.

Nikki Ken'ichi. *Gassen no butai-ura.* Tokyo, 1976.

Nishigaya Yasuhiro. *Senkoku daimyō jōkaku jiten.* Tokyo, 1999.

Ōmori Nobumasa. *Bujutsu densho no kenkyū.* Tokyo, 1991.

Sakamoto Tokuichi. *Takeda Shingen no hyakuwa.* Tokyo, 1987.

Shichinomiya Keizō. *Shimōsa-Okushū Sōma ichizoku.* Tokyo, 2003.

Shimura Kunihiro, trans. *Ōnin ki.* Tokyo, 1994.

Sugimoto Keizaburō. *Gunki monogatari no sekai.* Tokyo, 1985.

Sukeyama Naoki. *Nihon kengō retsuden.* Tokyo, 1983.

Takahashi Tomio. *Bushidō no rekishi.* Vols. 1–3. Tokyo, 1986.

Takano Samirō. *Kendō.* Tokyo, 1915.

Takemitsu Makoto. *Gassen no Nihon chizu.* Tokyo, 2003.

Watatani Kiyoshi. *Nihon kengō no hyaku sen.* Tokyo, 1990.

Yamada Hirohisa. *Zan'un: kōshū Minowa-jō no Kōbō.* Maebashi, 2004.

Yasuda Motohisa. *Kamakura, Muromachi jinmei jiten.* Tokyo, 1990.

Yokoi Kiyoshi. *Chūsei wo ikita hitobito.* Kyoto, 1981.

INDEX

Bold type indicates a page with an illustration

 Floating World Editions publishes books that contribute to a deeper understanding of Asian cultures. Editorial supervision: Mike Ashby. Book and cover design: William de Lange. Maps and charts: John de Lange. Production supervision: Bill Rose. Printing and binding: Malloy Incorporated. The typefaces used are Hoefler and Papyrus.